IMAGES
of America

CANTON TOWNSHIP

D1451999

On the cover: **CANTON BARN RAISING.** Members of rural communities like Canton Township often shared free labor in return for the promise of reciprocal commitment. Pictured at the William Smith farmhouse are Sheldon Corners neighbors who have helped the Smith family raise the all-important barn, a tradition dating to the 18th century in America. (Courtesy of Canton Historical Society.)

IMAGES
of America

CANTON TOWNSHIP

Gerald C. Van Dusen

ARCADIA
PUBLISHING

Published by Arcadia Publishing
Charleston, South Carolina

Printed in the United States of America

Library of Congress Catalog Card Number: 2006929354

For all general information contact Arcadia Publishing at:
Telephone 843-853-2070
Fax 843-853-0044
E-mail sales@arcadiapublishing.com
For customer service and orders:
Toll-Free 1-888-313-2665

Visit us on the Internet at www.arcadiapublishing.com

For Patti, Kristen, Lauren, Erin, and Steven

CONTENTS

ACKNOWLEDGMENTS

There are many people to thank for providing pictures, supplying historical information, and offering general encouragement.

For historical background I would like to thank Terry Bennett, Elaine Kirchgatter, Melissa McLaughlin, Dan Durack, Mike Ager, Joan Palmer, Deb Madonna, Bob Dates, and Dorothy Richards. I would particularly like to thank the late Charles Zasula for his many historical writings, Diane Wilson whose *Cornerstones* was a constant source of information about Canton families, and Joan Palmer for her useful volume, *Canton's Country Schools.*

I would like to acknowledge the Canton Historic District Commission, which had the foresight nearly 30 years ago to photographically document important Canton homes and institutions before they were demolished, and to the Canton Historical Society and Museum, which provided many excellent archival photographs of early Canton pioneers, schools, and farms.

A number of Canton families provided unique perspectives on early Canton life. For their family photographs I would like to thank Robert Padget, Marie Gentz, the Fischer family, Don Gill, Roxanne Gill, Dave and Debra Grammel, Conrad Dennis, Stephanie Dennis, Bonnie Berg, Robert Mettetal, Esther Scheppele, Scott Colf, Joan Palmer, Clark Keller, and Elaine Lavander.

Finally I am especially indebted to three individuals whose contributions and commitment were instrumental in seeing the project through to completion: David Curtis, Ronnie Curtis, and Ruth Wiles. On a weekly basis these three individuals helped me locate, identify, and evaluate important photographs of early Canton, and I wish to thank them here formally.

INTRODUCTION

The charter township of Canton, situated in southeast Michigan, approximately halfway between Ann Arbor and downtown Detroit, is one of the largest communities in southeastern Michigan. Its current population tops out at almost 85,000 and is expected to reach 107,000 by 2030. Canton is one of the region's few large communities that still has room to grow.

Canton owes its name, its history, and even its economy to special circumstances that settlers confronted early in the 19th century. The Erie Canal, known originally as the Great Western Canal, had opened up the interior of the United States to eastern settlers otherwise discouraged by the great physical barrier of the Appalachian Mountains. In many instances, early Canton settlers had followed this route from New England and upstate New York to the beckoning Northwest Territory. Detroit was a major point of entry, but many other trading posts along Lake Erie, such as Monroe and Flat Rock, gave these eventual settlers a manageable overland route.

On their way west, many of these pioneers traveled the Chicago Road, which followed the original route of the old Saulk Trail, an ancient Native American footpath. This new highway, known today as Michigan Avenue, would eventually cut across the southern section of the state, connecting Detroit with Fort Dearborn (Chicago).

Settlers like Philander Burd, taking a measure of the new land, discovered a heavy clay loam, natural streams and springs, and virgin timberland, a rich and fertile legacy of the Ice Age, perfectly suited for the subsequent farm economy that would create Canton's reputation for much of its history as "the Sweet Corn Capital of Michigan." In 1825, Burd obtained the first land grant, but he was followed in quick succession by dozens more.

Communities large and small developed along Michigan's first western thoroughfare. One such community, Sheldon Corners, grew up around a large inn built by Timothy Sheldon soon after his arrival in 1825. Located near the triangle created by the intersection of Chicago Road, South Territorial Road (now Geddes Road), and North Road (now Sheldon Road), the Sheldon Inn sheltered travelers moving west and became the hub of a burgeoning community of farm families and trades people.

Cherry Hill, Canton's other hamlet, developed under very different circumstances. Located at the junction of Cherry Hill and Ridge Roads, this quaint little village's main allure was the rich, productive soil, a by-product of an ancient lake bed whose ridge cut a diagonal path through the western edge of the township. By 1830 several families had settled "the Ridge," as it was popularly known, and the basic elements of community had begun to appear.

The Territorial Council of 1827 had decreed that townships of 50 or more inhabitants provide for schoolmasters "of good moral standing" to instruct the children in reading and writing.

Ten primary schools—rural one-room schoolhouses in which all grades were taught by a single schoolmaster—were established beginning in 1834.

On March 7, 1834, "Town 2 South, Range 8 East" was proclaimed a separate township, to be known thereafter as Canton. Two neighboring townships, Nankin (later Westland) and Pekin (later Redford), were likewise named after cities at the opposite end of the globe because, by territorial law, no new township could be named after an existing United States post office.

Until the mid-20th century, the main occupation in Canton Township was farming—first, subsistence farming, producing what was mainly needed for survival; second, general farming, raising livestock and cultivated grain; and third, commercial farming, selling a variety of farm products at local and regional markets, such as Kroger's Supermarkets and Detroit's Eastern Market.

The introduction of the automobile and the expansion of the freeway system led to a radical transformation of Canton Township's population and economy. Throughout the latter half of the 20th century, beginning in the east and spreading west, square mile after square mile succumbed to residential and commercial development.

Rural and graded schools were eventually consolidated following the provisions of Title XV of the Education Act of 1952. Five of the original one-room schoolhouses remain, performing various educational and cultural functions within the community. Canton is today home to the Plymouth-Canton Educational Park (PCEP), a 305-acre campus that houses three high schools (Plymouth, Canton, and Salem). Not only is PCEP the largest school of its kind in Michigan, boasting an enrollment of over 5,000 students, but it is the only such campus in the United States where three high schools coexist on the same campus.

In 1961, Canton voters approved a proposal to incorporate as one of Michigan's first charter townships. The new designation by law gave Canton new levying power to upgrade and enhance police and fire protection, professionalize township departments, broaden health ordinances, and establish a multifaceted recreational department. Canton is further served by an accredited school system and a full-service library and many volunteer and civic organizations.

Even as Canton back roads are dotted with new construction, both the township and private interests continue to preserve the memory of the past through important organizations such as the Historic District Commission and the Canton Historical Society, as well as through such significant restoration projects as Cherry Hill and Canton Center Schools, the Bartlett-Travis House, and most recently, the Cherry Hill Inn.

One

PIONEERS AND EARLY SETTLEMENTS

The earliest Canton settlers were able to purchase substantial acreage—up to 320 acres—for $2 an acre on a time-payment plan or $1.25 per acre without deferred payment. The Harrison Act of 1800 (revised 1820), which had set the price, and the opening of the Erie Canal in 1825, which opened the door, provided just the impetus needed for settlers from New York, New England, and even Europe to stake their claim in this fertile new land.

The conditions of the wilderness, however, exacted a heavy toll on the first generation of Canton settlers in particular. Clearing the land for that important first planting, hewing and hauling timber for both log cabin walls and for fuel, and hunting and trapping forest critters for meat and for pelts—these were activities that tested the body, the mind, and the very soul of these early settlers.

The first log cabins were of very crude construction. Typically they were 18 by 24 feet, with an animal skin or wooden batten door and a fireplace made of stone. These windowless homes were lit by homemade candles, accounting in part for the high number of accidental fires in those early days of settlement. If the fire in the fireplace went out, then the main source of heat was gone. In such instances, one member of the family would be dispatched to the nearest neighbor to borrow a live coal.

Another basic need was clothing. Pioneer women made the clothes for their families, and this involved spinning yarn and weaving clothes. Spinning wheels, looms, dye pots, and quilting frames occupied a prominent place in pioneer homes.

While life was hard for pioneers, much comfort and satisfaction was taken by knowing that a community of pioneers was forming and a support system was in place to help with bigger projects, such as barn raising and church building.

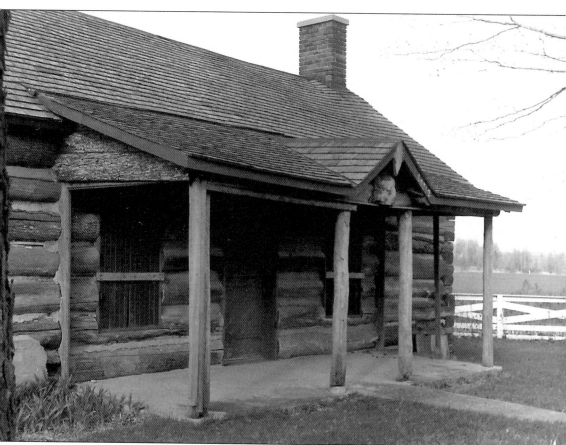

HOUGH CABIN INSCRIPTION. Inscribed on a brass place attached to a wall of the Hough cabin are the following words: "In the year 1825 at the opening of the Erie Canal, Ira Marshall Hough, together with Salmon Kingsley, a Revolutionary soldier, and his family migrated from the State of Vermont to the wilderness in the West known as the Territory of Michigan, and settled in this neighborhood. Kingsley located on what is now called Ann Arbor Trail and Hough settled here, built a log cabin on this site and married Kingsley's youngest daughter Adeline. The cabin he built was destroyed by fire in 1835, when he built the frame house nearby which has since been the Hough Homestead and from which a large family has migrated to other parts of the country. This cabin was built in 1904 by members of the second generation in grateful memory of those who left the comforts of an older civilization in the East to carve out a home from the forests here and make possible the security and comfort we now enjoy." (Courtesy of Plymouth Historical Society.)

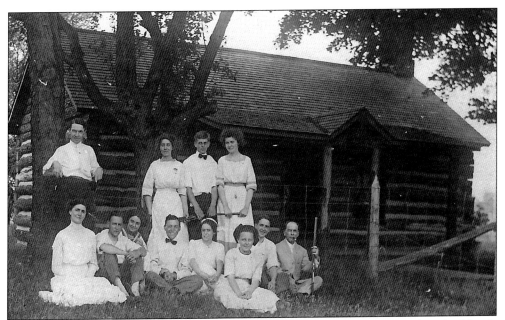

HOUGH REUNION. Hough cousins from around the state of Michigan returned to the Hough family cabin for a small reunion in 1910. Target practice with Daisy Air Rifles, manufactured by Ira Hough's nationally known manufacturing company in Plymouth, was part of the weekend's entertainment. (Courtesy of Plymouth Historical Society.)

HOUGH HOMESTEAD. Canton pioneers Ira Hough and Adeline Hough (née Kingsley) applied for an original land grant in the northeast section of Canton Township on March 7, 1826. After their initial log cabin burned to the ground in 1835, Ira built the wood frame house, pictured, that lasted for more than 130 years. The property was designated a Centennial Farm by the Michigan Historical Commission in 1949. The construction of I-275 required its demolition in the early 1970s. (Courtesy of Canton Historical Society.)

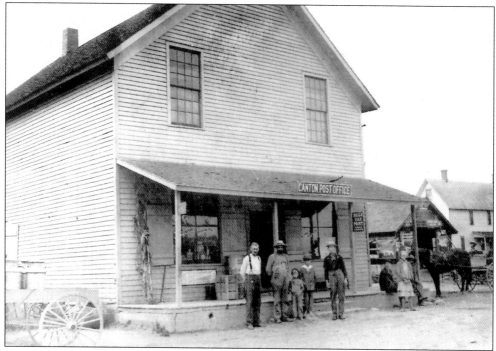

ORIGINAL WINSOR STORE. At Sheldon Corners, Zenas Winsor opened a general merchandising establishment in 1877. Along with the two churches, a one-room schoolhouse, a creamery, a blacksmith shop, a cobbler, and an inn, Sheldon Corners came to possess all the necessities of a village center. (Courtesy of Canton Historical Society).

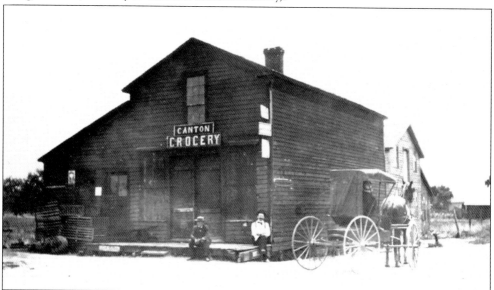

JOSLIN STORE. In 1879, two years after the Winsor Store debuted, Samuel Joslin's establishment opened for business on the opposite (north) side of Michigan Avenue, just east of Sheldon. The competitive nature of the two stores spilled over into politics. When the Democrats dominated locally, Winsor became postmaster; when Republicans dominated, local residents had to go to the Joslin store for their mail. (Courtesy of Canton Historical Society.)

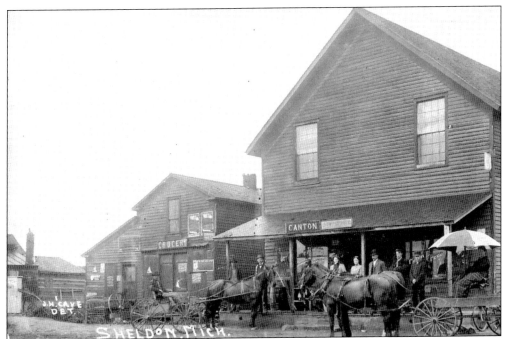

LATER WINSOR STORE. Sometime after 1908, Zenas Winsor purchased and moved the Joslin Store from its original north Michigan Avenue location to the vacant lot next to his existing store on the south side of Michigan Avenue. After it was razed, John Fischer built a cement block building that would eventually become the Sheldon Supermarket. Today the same building houses the BLOCK, a Canton Township teen center. (Courtesy of Canton Historical Society.)

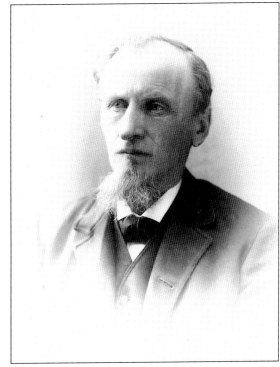

MICHAEL FISCHER. At his parents' insistence, Michael left his Wurtenberg, Germany, home at the tender age of 14 to avoid military conscription. After a harrowing 90-day ocean voyage, Fischer made his way to Canton via the Erie Canal and eventually settled in Sheldon Corners. (Courtesy of the Fischer family.)

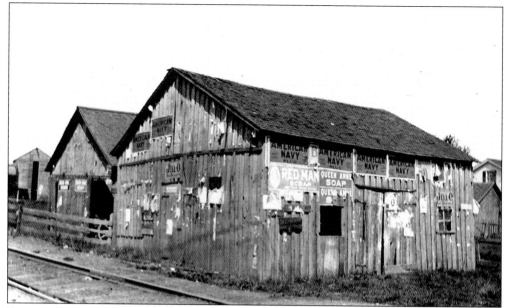

FISCHER BLACKSMITH SHOP. Michael Fischer earned his livelihood in Sheldon Corners as a blacksmith, and his very successful business was located on Michigan Avenue, west of Sheldon Road, next to the interurban tracks. (Courtesy of the Fischer family.)

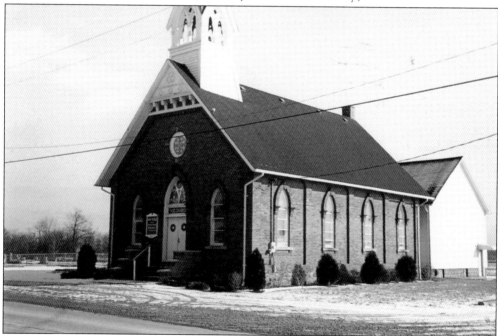

CHERRY HILL UNITED METHODIST CHURCH. Located at 321 South Ridge Road and built in 1882, this early Canton church is both a Michigan and a Canton historic site. The Methodist congregation was founded in 1834 and was serviced by a circuit rider. The church is Gothic Revival and designed by the same architect who designed the Canton Center School. The bricks were handmade on the Cobb farm, located on Proctor Road. In 1981, the church was restored to celebrate its centennial. (Courtesy of Canton Historical Society.)

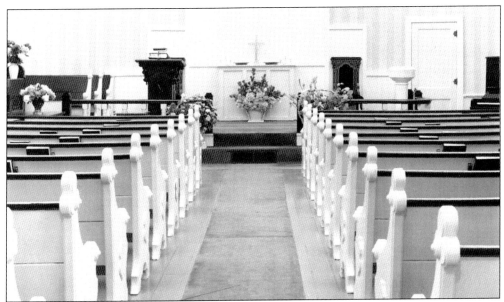

CHERRY HILL METHODIST CHURCH, INTERIOR VIEW. Pictured are the original pews within the nave, or congregational sitting area of the church. At the front is the sanctuary, from where the service is conducted. On either side, not in view, are stained-glass windows etched with the names of pioneering families. (Courtesy of Canton Historical Society.)

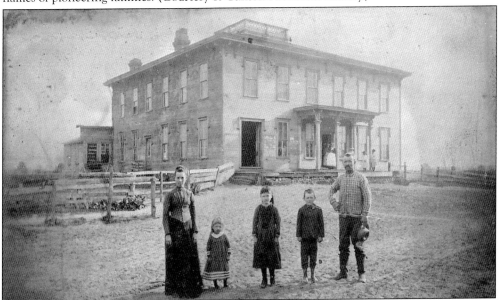

CHERRY HILL HOUSE. Shortly after the Civil War, Abner Hitchcock, a veteran hotelier from New York State, built this grand hotel complex at the corner of Ridge and Cherry Hill Roads. Hitchcock believed that the planned Chicago Turnpike, linking Chicago to Detroit, would run along Cherry Hill Road, thus making his well-appointed inn a convenient and lucrative stop-off. When the turnpike was finally constructed along the old Saulk Trail, instead of Cherry Hill Road, "Hitchcock's Folly" foundered, and Hitchcock went broke. In the photograph above, from left to right, stand Catherine Gunn (née Burns), Katie, Maggie, John F., and subsequent owner James Gunn. (Courtesy of Canton Historical Society.)

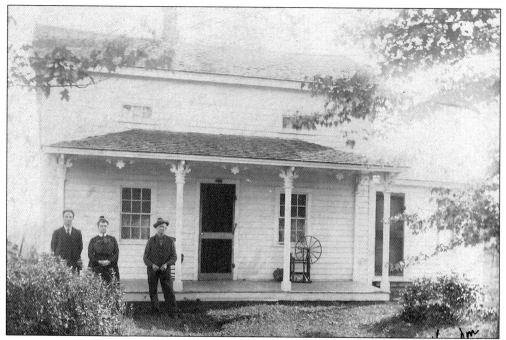

HARMON HOUSEHOLD. Standing in front of the Warren Road home of Theodore Harmon are, from left to right, son-in-law Juel Travis, daughter Ethel Travis (née Harmon), and Theodore. The grandson of settlers Hiram Harmon and Jane Harmon (née Berdan), Theodore collected antiques as a hobby and occasionally displayed on his front porch a barrel that he claimed had been used by the first person to go over Niagara Falls. (Courtesy of Canton Historical Society.)

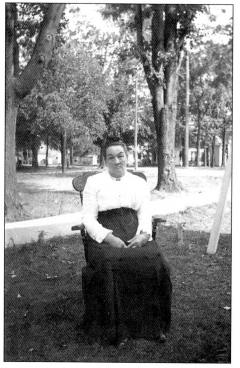

ANNE MORTON (NÉE HUNTER), c. 1900. Wife of Charles, and mother of 11 children, Anne Morton and her husband purchased the former Sheldon Inn from Timothy Sheldon's nephew, Charles Sines, and would eventually contribute their family name to Morton-Taylor Road. (Courtesy of Canton Historical Society.)

JOHN FISCHER AND EDNA FISCHER (NÉE TRUESDELL). Michael Fischer's only son, John George, married Edna Emma Truesdell on December 28, 1892, and subsequently purchased a farm on the west side of Sheldon Road just south of Sheldon Corners. (Courtesy of the Fischer family.)

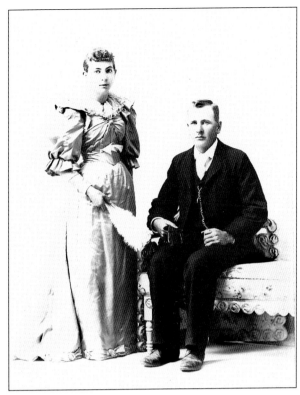

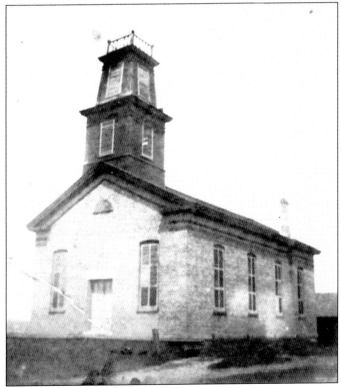

FIRST METHODIST CHURCH AT SHELDON. For a sum of $10, Philip and Aurilla Sines deeded over a portion of their property, located on the northeast corner of Territorial (Geddes) and Sheldon Roads, to trustees of the Canton Methodist Church on April 14, 1845. Thirteen years later, the church was finally built. (Courtesy of Canton Historical Society.)

17

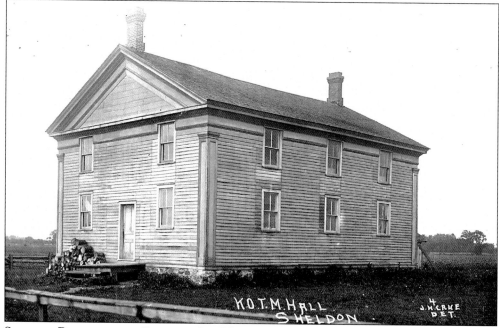

SHELDON PRESBYTERIAN CHURCH. On February 3, 1849, William and Mary Smith deeded a piece of their newly purchased property to the trustees of the First Presbyterian Society of Canton. The next year, possibly a few years later, the trustees approved the construction of a Greek revival edifice on the northwest corner of Territorial (Geddes) and Sheldon Roads, just across the street from the First Methodist Church. Later the building was used as a meeting place for the Knights of the Maccabees and as a Grange hall. (Courtesy of Canton Historical Society.)

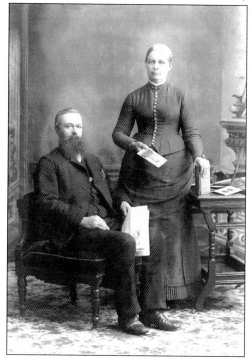

ROBERT L. HUSTON AND JANE ANN HUSTON (NÉE COMER). The first Michigan-born child of John Huston and Laura Huston (née Bentley), Robert was the grandson of New York State pioneering couple William Huston and Mary Huston (née Winder). In the tradition of the Hustons, Robert and Jane parented several children who eventually intermarried into several well-known local families. (Courtesy of Canton Historical Society.)

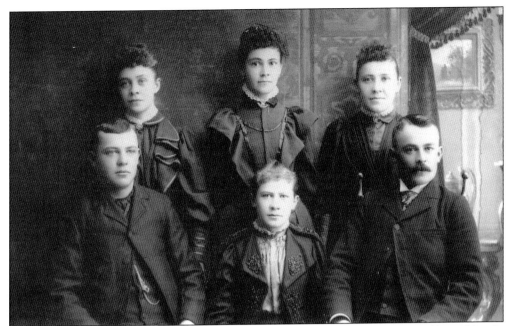

THE JACOB HASSELBACHS, c. 1890. From left to right are (first row) Frederick, Stella, and Jacob; (second row) Ida, Julia, and Sarah. Jacob was one of eight children born to pioneers Christopher Hasselbach and Julia Hasselbach (née Becker) of Hesse Damstadt, Germany. (Courtesy of Canton Historical Society.)

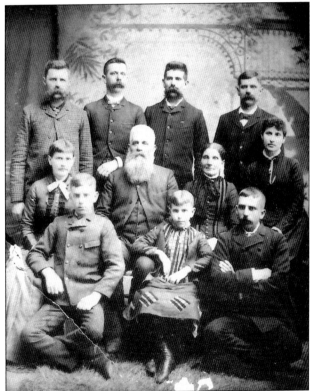

FORSHEE FAMILY, 1888. Canton pioneers Henry Forshee and Eliza Jane Forshee (née Tibbetts), who settled on the site of one of Canton Township's first two land grants, at the southwest corner of Joy and Beck Roads, pose in this photograph with 9 of their 11 children. From left to right are (first row) Cub, Winnie, and Ezra; (second row) Mary, Henry, Eliza Jane, and Addie; (third row) George, John, Frank, and Fred. (Courtesy of Canton Historical Society.)

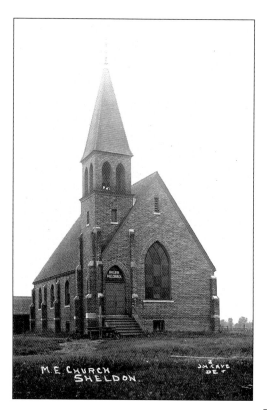

M.E. CHURCH SHELDON

SECOND METHODIST CHURCH AT SHELDON. Although an exact date of construction has not been determined, the First Methodist Church was replaced by a brick structure as early as 1876 and possibly as late as 1898. (Courtesy of Canton Historical Society.)

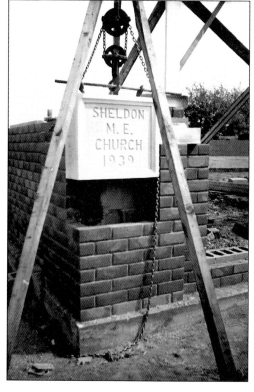

LAYING THE CORNERSTONE, THIRD SHELDON METHODIST CHURCH. In 1939, the cornerstone was laid for the Third Methodist Church of Sheldon Corners. Constructed of brick manufactured at the John S. Haggerty brickyard in Springwells, the church sits today on the site of the two previous Methodist churches. (Courtesy of the Fischer family.)

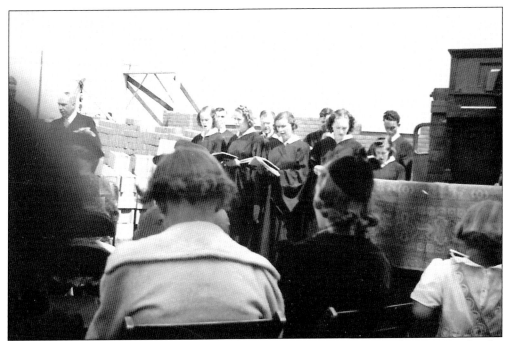

Third Sheldon Methodist Church, Cornerstone Dedication Ceremony. At the cornerstone dedication ceremony on May 21, 1939, a choir performs for the assembled church officers and members. (Courtesy of the Fischer family).

Third Methodist Church at Sheldon. Following a fire in 1937, which completely destroyed the Second Methodist Church, a third Methodist church was built and formally dedicated on May 21, 1939. All three Methodist churches stood on approximately the same site. Today Grace Baptist Church occupies the premises. (Courtesy of the Fischer family.)

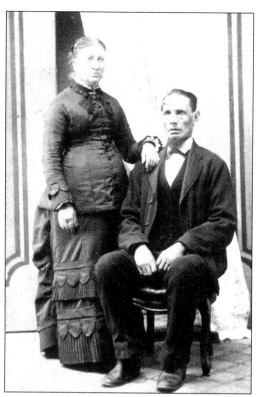

GEORGE E. PALMER AND ELIZABETH PALMER (NÉE KEY). The pioneering Palmers married in England on December 16, 1849. George came to America to establish a home for his bride, which was located in the northeast section of Canton on Haggerty Road, just north of Koppernick Road. A family bible was given them as a parting gift to be passed on from youngest son to youngest son. (Courtesy of Canton Historical Society.)

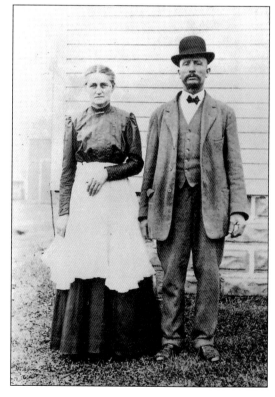

MELVIN PALMER AND MARY PALMER (NÉE ERDMAN). The youngest son of Canton pioneers George and Elizabeth Palmer, Melvin left his Lotz and Palmer Roads farm with his wife and six children to move about, including a four-year stay in the San Francisco area. When the great earthquake struck on April 18, 1906, the Palmers decided to return to Canton and purchased a farm at 563 South Canton Center Road. (Courtesy of Canton Historical Society.)

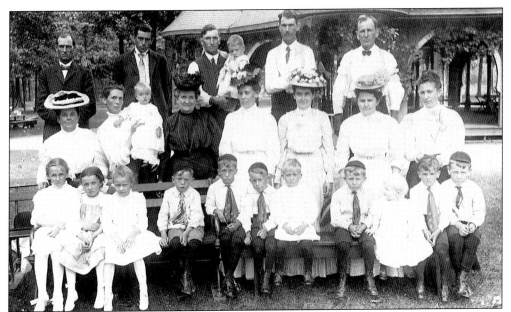

TRUESDELL-GILL PICNIC, 1900. Sitting in the first row from left to right are Naomi Beadle, Ruth Freeman, Emma Smith, Glen Truesdell, Alfred Truesdell, Gordon Gill, three unidentified, Charles Truesdell, and unidentified; (second row) Elizabeth Sayre, Mable Truesdell holding Jimmie, Emma Truesdell, Grace Gill (née Sayre), Eleanor Smith, Minnie Freeman, and Edna Fischer; (third row) Louis Truesdell, George Gill, Jesse Smith holding William, Charles Freeman, and John Fischer. (Courtesy of the Gill family.)

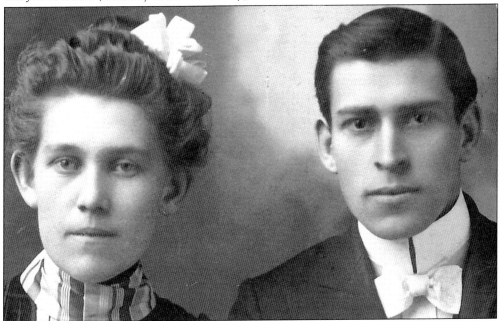

GRACE GILL (NÉE SAYRE) AND GEORGE GILL, 1900. Son of Peter Gill and Jennie Gill (née Lewis), George taught at Sheldon School and married Grace Sayre on November 29, 1899. The two would settle down on Ridge Road and raise two sons, Gordon and Charles. Both were very active in the Cherry Hill Methodist Church. (Courtesy of the Gill family.)

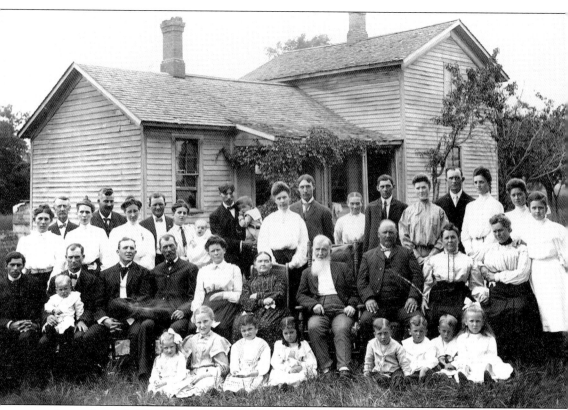

James Lilley's 90th Birthday Celebration, July 2, 1905. From left to right are (first row) unidentified, Irene Ross (née Haak), Ella Ried (née Barker), Nettie Walker (née Barker), Alfred Truesdell, Charles Truesdell, Gordon Gill, and Naomi Beadle (née Truesdell); (second row) George Gill, Louis Truesdell holding Louis Jr., Bert Millspaugh, Charles Sayre, Jane Millspaugh (née Lilley), Frances Elizabeth Sitlington (née Lilley), James Lilley, William Lilley, Elizabeth Sayre (née Lilley), and Sarah Mary Lilley (née Post); (third row) Grace Gill (née Sayre), unidentified, Mable Truesdell (née Sayre), Edward Barker, Ada Millspaugh, Robert Sitlington, Daisy Mott (née Lilley) holding Marion, Bert Mott holding Maynard, Susie Millspaugh, unidentified, Irene Haak, Laverne Sayre, Maude Lilley, Floyd Lilley, Elizabeth Clippert (née Liley), Stella Chambers (née Lilley), and Lana Robinson (née Liley). (Courtesy of the Gill family.)

HUSTON FAMILY REUNION, 1935. From left to right are (first row) ? Ballard (mother-in-law of Elmer Huston); Edson Austin Whipple; Edson Oscar Huston; Luella Huston (née Hoyt), Edson's second wife; Mary Huston (née Brooks), wife of Elmer; and Elmer Huston; (second row) Oscar Metcalf Huston; Elmer Rikenecker; Mary Rikenecker; Orson Atchinson; Naomi Atchinson (née Huston); Arthur E. Huston; Arthur Johnson, son of Iva Huston Johnson; and Ruth Whipple (née Huston). (Courtesy of Canton Historical Society.)

GOLDEN WEDDING ANNIVERSARY OF FRED AND ODELIA PALMER. On November 8, 1948, four generations of Palmers helped Fred and Odelia Palmer celebrate 50 years of marriage at the Fred Palmer residence. Fred is sitting to the far right, holding a cane, and Odelia is seated second from right, next to Fred. (Courtesy of Canton Historical Society.)

THREE GENERATIONS OF GILLS. Standing from left to right are Grace (grandmother), Don (grandson), Gordon (son), George (grandfather), Stan (grandson), and Charles Gill (son). (Courtesy of the Gill family.)

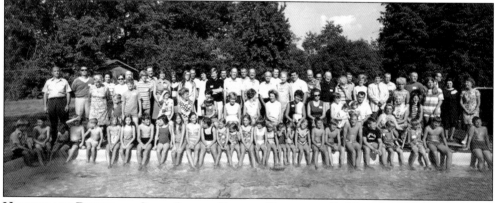

HASSELBACH-DINGELDEY-STEIN-SMITH FAMILY REUNION. Emblematic of the historical interdependence of Canton farm families, the photograph above celebrates the continued close relationships among the descendants of Canton pioneers. Held at the Michigan Avenue home of Andrew Smith and Marie Smith (née Stein), casually dressed family members are gathered by the Smith family swimming pool. Six decades earlier, on Saturday, August 11, 1906, the Hasselbachs had celebrated their first family reunion, held at the farm of Mary Dingeldey (née Hasselbach) on Haggerty Road. (Courtesy of Canton Historical Society.)

Two

COUNTRY SCHOOLS AND EARLY EDUCATION

One of the first acts of community in Canton Township was to provide for the formal education of its children. During the mid- to late 19th century, nine primary schools opened in Canton. Primary schools were rural, one-room schools in which a single teacher taught all grades. As school districts increased in size, a second teacher was hired at each school to share the teaching responsibilities.

Typically located at the intersection of main roads, the first schoolhouses were crude, log cabin structures heated in the winter by wood-burning fireplaces. Water was supplied by water pail and dipper, and privies were located behind the schools.

The curriculum in these early schools was unsophisticated by today's standards, but children were well schooled in the basics, such as reading and writing, penmanship, geography, and arithmetic. At Cherry Hill School, funded by Henry Ford as part of his village industries operation, students had the opportunity to also learn different fabric and woodcrafts.

By the mid-20th century, Canton residents voted to annex the original rural school districts into the larger consolidated school systems. In 1955, many of the smaller districts in Canton were consolidated and renamed the Plymouth Community School District.

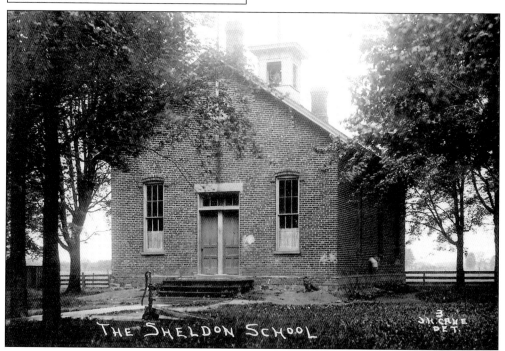

SCHOOL DISTRICT NO. 1 CENSUS, 1846. The first students had been admitted to Hough School in 1827 where Mary Barber and Emily Brown greeted students and alternated teaching duties until 1839. Mary Barber returned to teaching in 1846, at the time the census at left was recorded. (Courtesy of Canton Historical Society.)

SHELDON SCHOOL, c. 1890. Sheldon School was located on the south side of Michigan Avenue between Sheldon and Canton Center Roads in the northwest quarter of section 34 and was called Fractional District 1 of Canton and Van Buren. Today the building houses a Head Start program. (Courtesy of Canton Historical Society.)

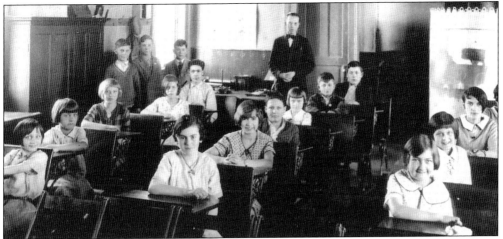

SHELDON SCHOOL, 1928–1929. Pictured here, standing in the back from left to right, are Bill Pill, Jerome Walker, an unidentified boy, and Roy Schofield (teacher). The students seated at their desks, from front to back, are (first row) Ranetta McClear, Pauline Pill, unidentified, Ruth Barker, and Lewis Bakos; (second row) Florence Avery, Maxine Merryfield, George Bacus, Doris Longwith, and two unidentified; (third row) Gladyse Besore, unidentified, Mary Crisovan, and Anne Crisovan. (Courtesy of Canton Historical Society.)

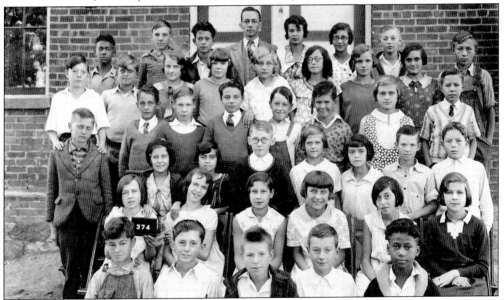

SHELDON SCHOOL, 1931–1932. Shown here from left to right are (first row) Russell Crisovan, John Herber, Harry Powers, Ferris Busha, and Therlow Simons; (second row) Lucille Morgan, Maxine Morgan, Olga Dabich, Violet Komnenovich, Rosie Goldstein, and Doris Robbe; (third row) Mary Wood, Margaret Townsley, Donald Longwish, Bertha Nickolas, Germaine DeBaker, Bobby Powers, and Leslie McCoy; (fourth row) Vernon Case, William Dicks, Frank Wood, Tom Crisovan, unidentified, Robert Cross, Hilda Nickolas, and Arthur Huston; (fifth row) unidentified, Mike Nickolas, Doris Longwish, Ruth Randall, Anne Mikeska, Regina Goldstein, Lillian Poet, Lois Dunn, and John Mikeska; (sixth row) William Simons, Jerome Walker, Richard Barker, Jack Beadle (teacher), Ann Crisovan, Helen Dabich, and Clifford Matevia. (Courtesy of Canton Historical Society.)

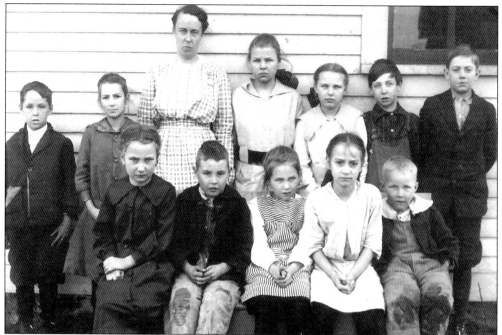

BARTLETT SCHOOL, 1917–1918. Pictured here from left to right are (first row) Ruth Root, Edwin Utter, Henry Burc, ? Hallowell, and Irving Utter; (second row) Delbert Avery, ? Hallowell, Hattie Corwin (teacher), Mabel Blackmore, Ruby Utter, unidentified, and Henry Hutton. (Courtesy of Canton Historical Society.)

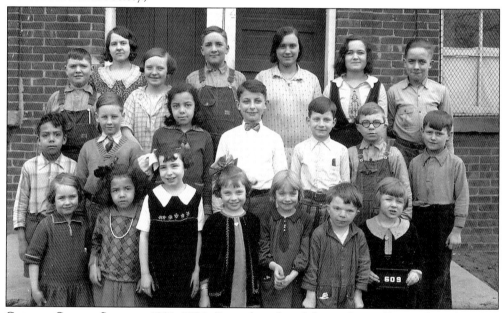

CANTON CENTER SCHOOL, 1931–1932. Posing here from left to right are (first row) unidentified, Jean Dean, Myrtle Schrader, two unidentified, James Franklin, and unidentified; (second row) Robert Dean, unidentified, Eleanor Dean, Henry Fawl, ? Wood, William Franklin, and ? Wood; (third row) John Wiles, Robbie Wilson (teacher), Myrtle Franklin, Donald Wiles, unidentified, Alice Funk, and unidentified. (Courtesy of Canton Historical Society.)

MARIE COX WITH HER CHEVROLET BEL-AIR. Canton Center School teacher Marie Cox taught at the school from 1945 until 1955, at which time it consolidated with Plymouth Township Schools. (Courtesy of Canton Historical Society.)

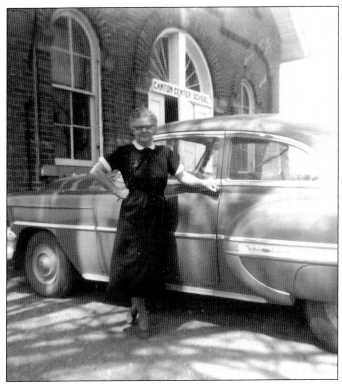

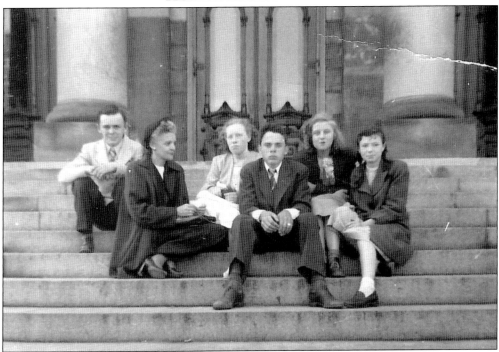

CANTON CENTER EIGHTH-GRADE GRADUATION TRIP TO LANSING, 1948. Sitting on the steps of the state capitol building are, from left to right, Bill Clixby, Marie Cox (teacher), Mary Jane Rea, Bill Runge, Joyce Duff, and Kathryn Richards. (Courtesy of Canton Historical Society.)

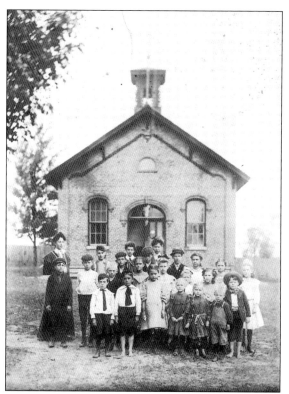

CHERRY HILL SCHOOL, 1904–1905.
Pictured here from left to right are (first row) three unidentified students, Marion Holmes, Mildred Holmes, and Alfred R. West; (second row) Solon Holmes, two unidentified boys, Florence Holmes, two unidentified girls, Elzie Holmes, and Lloyd Bordine; (third row) Minnie Horner (teacher) and the other students remain unidentified. (Courtesy of Canton Historical Society.)

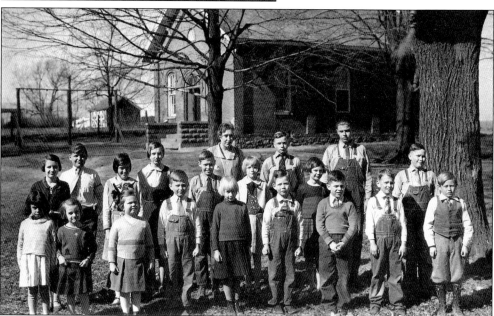

CHERRY HILL SCHOOL, 1932–1933. From left to right are (first row) Doris Cook, Vernagene Kruger, Ada Marian Byland, Ross Hauk, June Dorey, Bruce Jorgensen, Spencer Grummel Jr., Donald Gill, and A. K. Cook; (second row) Una Kruger, Harold Stobb, Marie Fraser, Phyllis Wilkie, Roger Bordine, Alta Fisher (teacher), Ellen Jorgensen, William Hawker, Bette Gotts, Gerald Bordine, and Robert Hawker. (Courtesy of Canton Historical Society.)

CHERRY HILL SCHOOL, LAST GRADUATING CLASS, 1954–1955. From left to right are the following: (first row) Robert Schultz, Jeanette Ridley, Barbara Mulhern, Gail O'Donnell, Claudiea Kessler, Elizabeth Engle (teacher), Mardue Hood, Louise Clem, Roderick Wright; (second row) Charles Houk. (Courtesy of Canton Historical Society.)

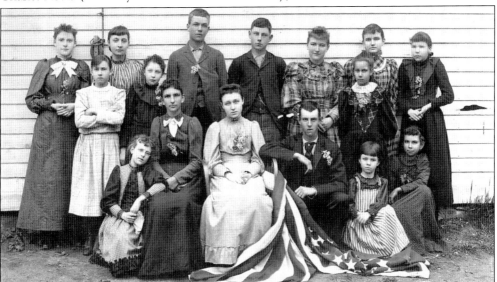

HANFORD SCHOOL, 1892–1893. Pictured from left to right are (first row) Sara Bradford, Bertha Quartel, Edith Sayles (teacher), Walter Sherman, Emeline Manzer, and Etta Quartel; (second row) Alma Murray, Mabel Patterson, and Millie Jackson; (third row) Anna Sly, Ada Westfall, Leonard Cross, Willard Pooler, Mattie Walker, Alice Cross, and Sadie Peterson. Several students were absent. The flag was purchased by the school and raised on Columbus Day, October 12, 1892, the first flag to be raised over this schoolhouse. Exercises were held commemorating the 400th anniversary of the discovery of America. (Courtesy of Canton Historical Society.)

33

School
Souvenir

Whether on the tented field

Or in the battle's van,

The fittest place for man to die

Is where he dies for man.

HANFORD SOUVENIR, 1921. Teacher Esther Wiseley taught at Hanford School for two years. At the end of the 1920–1921 academic year, she presented to each of her 21 pupils an inspirational souvenir to remember her and the school. (Courtesy of Marie Gentz.)

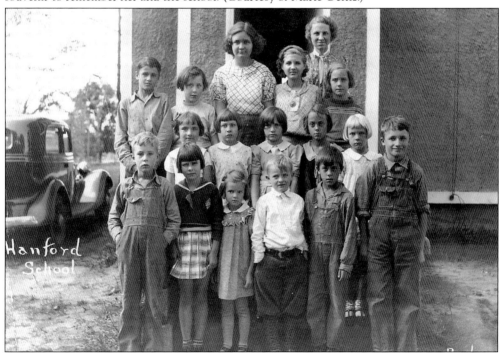

HANFORD SCHOOL, 1936–1937. From left to right are the following: (first row) Alton Miller, Dolores Danes, Barbara Finnegan, Richard Palmer, Vincent Ferrari, and Cliff Wilkin; (second row) Marie Duthoo, Virginia Waldecker, Betty Orr, Evelyn Ferrari, and Doris Waldecker; (third row) Byron Wilkin, Roberta Orr, Bernice Paskievitch, Glenna Clark, and Jenette Paskievitch; (fourth row) Elsie Smith (teacher). (Courtesy of Canton Historical Society.)

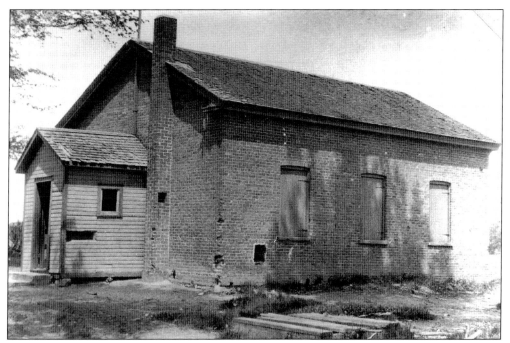

WALKER SCHOOL, 1859–1924. The above-pictured Walker School served the community for 65 years before being demolished and replaced with a new structure the next year, costing approximately $20,000. (Courtesy of Canton Historical Society.)

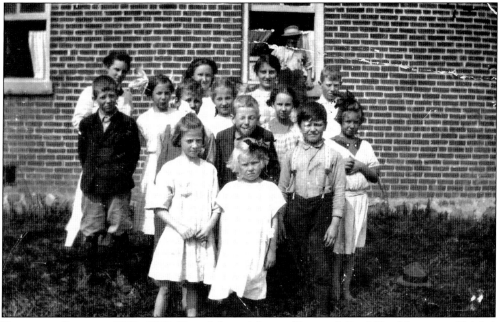

BARTLETT SCHOOL, 1912–1913. From left to right are (first row) Opel Harshbarger and Mabel Blakemore; (second row) Oren Blackmore, Wert Drayton, and John Bordine; (third row) Ollie Drayton, Nellie Blackmore, Blanche Hotton, Ursula Avery, and Avis Blackmore; (fourth row) Carrie Switzer (teacher), Mabel Avery, Nellie Link, and unidentified. Sitting in the window is Guy Harshbarger. (Courtesy of Canton Historical Society.)

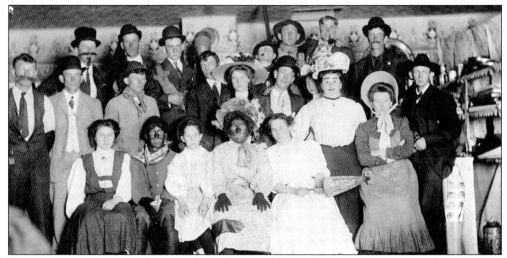

HOUGH SCHOOL, 1904, SCHOOL PLAY. Most of the students pictured cannot be positively identified because of the costuming and grease paint. The following students, listed randomly, can be spotted: Ethel Bolton, Lettie Anderson, Perry Hix, Elizabeth Truesdell, Nina Truesdell, Zaida Bolton, and Leander Truesdell. (Courtesy of Canton Historical Society.)

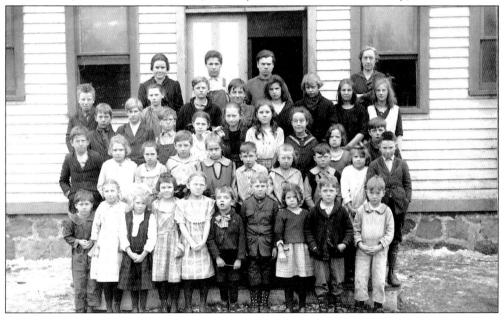

HOUGH SCHOOL, 1921–1922. From left to right are (first row) Stanley Truskowski, Flora Gerst, Ellen Buehler, Luella Swegles, Pauline Gust, Raphael Mettetal, Zigmund Przybylowski, Esther Merriman, Lester Reddeman, and William Lane; (second row) Arthur Kreeger, Eleanor Spisz, Mary Truskowski, Robert Pocket, Persis Fogarty, Harold Brown, Mildred Pocket, William Kennedy, Tracy Spisz, and Leroy Tillotson; (third row) Carl Fogarty, Edward Przybylowski, Felix Truskowski, Phila Gust, Lottie Szymanowski, Crystal Swegles, Genevieve Witt, Jeanette Merriman, and Conrad Kreeger; (fourth row) James Knapp, Martha Truskowski, John Kramer, Anthony Kreeger, Mary Merriman, Lottie Kaiser, Jennie Przybylowski, and Wanda Przybylowski; (fifth row) Thelma Swegles, Wilford Bunyea, Tony Truskowski, and Carrie Tillotson (teacher). (Courtesy of Canton Historical Society.)

Three

LIFE ON THE FARM

Throughout its first century, Canton Township was a checkerboard of large farms and regularly spaced roads. Farms were typically 40, 80, or 160 acres, consistent with federal law that made fractions of a square mile the unit of purchase.

Pioneering farm families were preoccupied with survival—fulfilling such basic needs as food, shelter, and clothing. Over the years, Canton farms evolved into more sophisticated operations, typically growing a variety of crops and raising different types of livestock.

Before mechanized farming, oxen were the beasts of burden, and they served as the tractors—pulling stumps, plowing fields, hauling loads, and skidding logs. According to the agricultural censuses of 1850 and 1870, the use of oxen declined on Canton Township farms from a high of 250 in 1850 to only 24 in 1870. Horses became the predominant beast of burden on Canton farms until the advent of the tractor.

With time and mechanization came farm specialization. Wheat had been, perhaps, the most important cash crop during Canton's first century. However, after 1920, and for the next 50 years, Canton became known for its dozens of major sweet corn growers as well as several large dairy operations.

Farm life in Canton was a yearlong buzz of activity. In the spring, crops were planted; in the summer the cattle were usually left on pastureland to graze; in the winter farm machinery was repaired and cattle were fed. No matter the season, however, daily farm chores occupied the entire family—gathering eggs, feeding the animals, fixing things around the farm, milking the cows, and caring for the livestock.

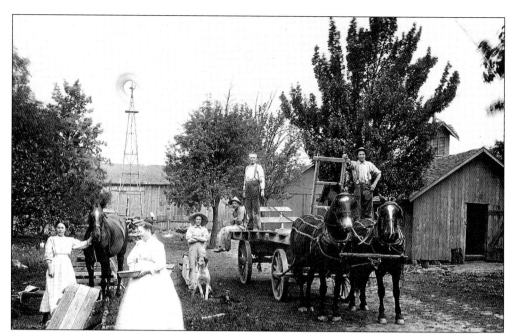

LIFE ON THE MOYER FARM, c. 1920. Daily life on a country farm consisted of chores shared by the entire family, male and female, young and old. Here the Elam Moyer family is pictured on its Hanford Road farm sharing the duties of a busy workday.

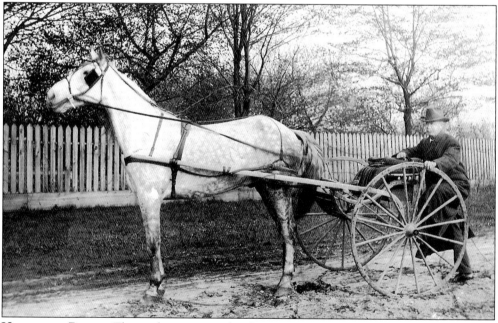

HORSE AND BUGGY. The predominant mode of transportation within the township remained the horse and buggy until the early decades of the 20th century when the horseless carriage began to revolutionize transportation. In this photograph, Eli Mettetal prepares to journey to Canton Township from his Redford home to visit with his son Raphael and daughter-in-law Stella, who had just purchased property to reestablish their greenhouse business. (Courtesy of the Mettetal family.)

SARAH BOLTON (NÉE OLIVER) ON THE HOUGH FARM. Some time after 1883, Sarah and her husband Benjamin lived as tenant farmers at the Edward Hough farm on the corner of Haggerty and Warren Roads. Together they raised five children on the Hough farm, Edward, Zaida, Clifford, Ethel, and Cass. (Courtesy of Canton Historical Society.)

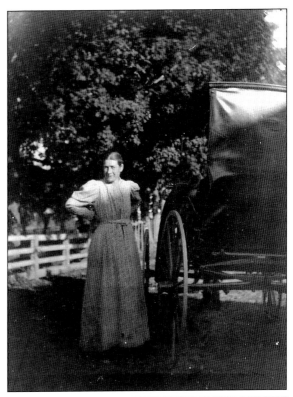

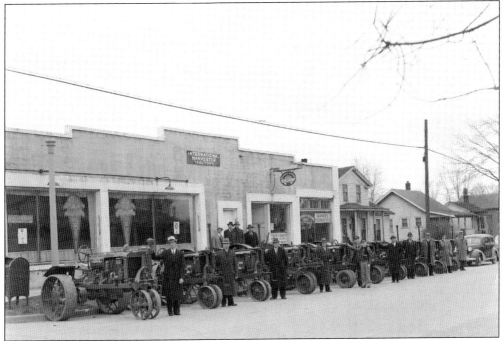

SPENCER GRUMMEL SR., POSING WITH TRACTOR IN PLYMOUTH. At the International Harvester store in Plymouth, Spencer "Buster" Grummel agrees to a promotional picture, along with other local farmers, for the manufacturer of farm implements. (Courtesy of the Grummel family.)

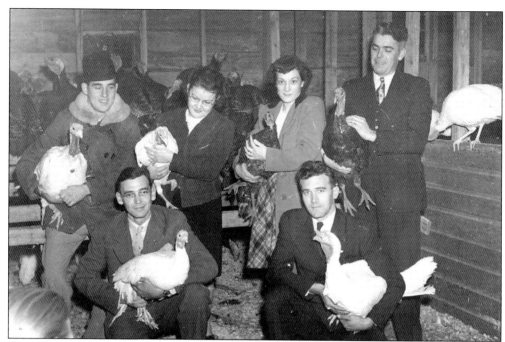

BART BERG TURKEY FARM, 1946. Shown here from left to right are (first row) Chris Berg (Bart's father) and Bart Berg; (second row) Bob Parker, Dorothy Mortsfield, Audrey Bye, and Al Adams. Bart Berg moved to Canton around 1941 to farm and raise poultry for his thriving Dearborn market. (Courtesy of Canton Historical Society.)

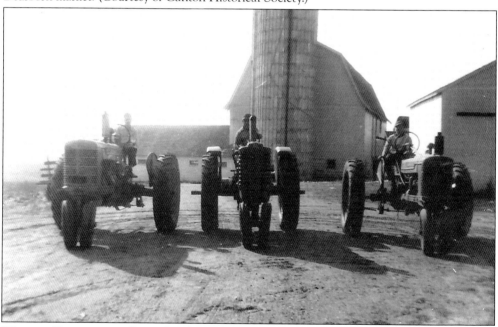

WARREN PALMER AND SONS. In this 1947 photograph, Warren Palmer sits atop the center tractor, next to son Russ, who is on the tractor on the right, and son Dick, on the tractor on the left. Warren was the grandson of Canton pioneers Aaron Palmer and Eliza Palmer (née Knaggs), who settled in Canton in 1833. (Courtesy of the Palmer family.)

FREEMAN HASSELBACH AND HELEN HASSELBACH (NÉE DUBKE). Since 1852 when Christopher Hasselbach and Julia Hasselbach (née Becker) settled the extreme southeast corner of Canton Township, the ancestral farm remained in family hands through four generations. During the 1950s, it became the first farm in Canton to receive a Centennial Farm designation, indicating that it had been owned and operated by the same family for at least 100 years. Here the Hasselbachs, Freeman and Helen, raised four sons and one daughter. They would eventually be the grandparents of 15 grandchildren and four great-grandchildren. (Courtesy of Canton Historical Society.)

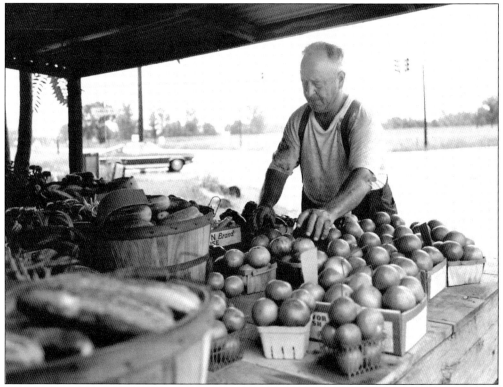

HASSELBACH FARM GARDEN STAND. Corn, wheat, oats, chicken, hogs, and dairy cows were raised on the Hasselbach farm. The bulk of their milk was taken to a weighing station in Romulus. They also sold milk directly from their farm to local residents for 15¢ a gallon. Pictured above, Freeman Hasselbach sells his own produce at his summer roadside garden stand. (Courtesy of Canton Historical Society.)

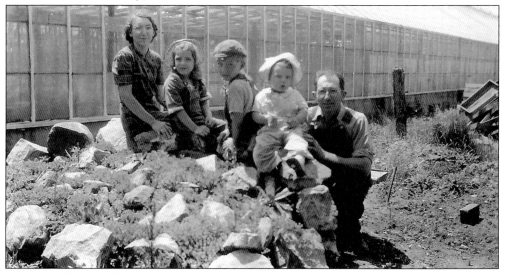

CLARENCE FISCHER FAMILY. Sitting in front of the greenhouse on the Fischer family farm are, from left to right, Charlotte Fischer (née Walker), Shirley May, Clarence John, Louis James, and Clarence Fischer. (Courtesy of the Fischer family.)

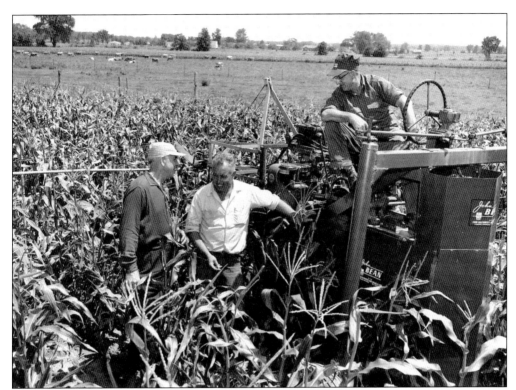

PEST CONTROL MEETING. M. L. Kirchhoff, left, a Plymouth farm implement dealer, chats with Melvin "Bud" Corwin and Warren Palmer, who is seated on the sprayer he purchased. Such meetings were held frequently with farmers and suppliers in Canton to check progress in their war against pests that thrived on the bountiful sweet corn crop. (Courtesy of the Grummel family.)

CAULIFLOWER KING. In addition to owning and operating several greenhouses on his sizeable Canton farm, Ray Mettetal grew a variety of produce and was known, both in Canton and at stall number 100 of the Western Market, as "the Cauliflower King." (Courtesy of the Mettetal family.)

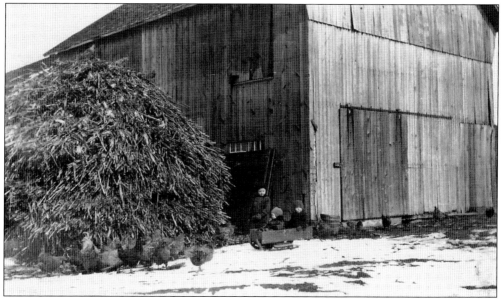

METTETAL HAY BARN. Loose hay used for animal feed was usually taken from the pasture to an area designated for stacking—often a slightly raised area for drainage—and either built into a haystack, as illustrated here at the Mettetal farm, or stored inside the barn. The hay would compress and cure under its own weight. Playing near the haystack are three of the Mettetal children and a rafter of turkeys. (Courtesy of the Mettetal family.)

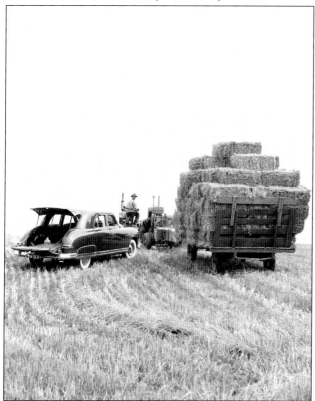

GATHERING AND BALING STRAW. Straw is the material that remains after a seed crop—such as wheat, oats, rye, barley, or rice—has already been harvested. Pictured at left, Spencer "Buster" Grummel gathers and bales the straw in one process with a baling machine. (Courtesy of the Grummel family.)

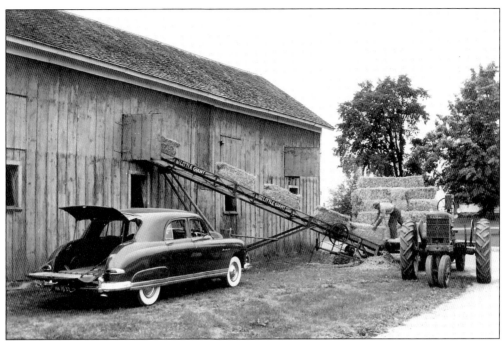

SPENCER GRUMMEL JR., STORES STRAW IN BARN. Rectangular bales of straw are dropped onto a conveyor belt to be stored above the ground for use during a long Canton winter. Smaller, rectangular bales were typically used on Canton farms as bedding for livestock or, in some instances, as insulation around the farmhouse proper. (Courtesy of the Grummel family.)

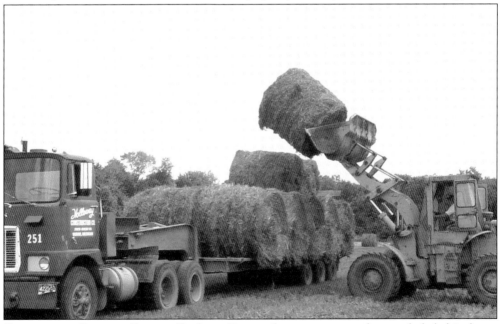

COMMERCIAL SALE OF STRAW. On large Canton farms, straw was frequently baled in large, round bales of roughly one to two yards in diameter and sold commercially for mulch, basketry, or decorative uses. Pictured here, large round bales are being loaded onto a truck for commercial redistribution. (Courtesy of Canton Historical Society.)

ROUND VERSUS RECTANGULAR BALES. Straw is baled in various sizes and shapes. On a typical Canton farm, straw was baled for direct use on the farm, such as for bedding or for sale to commercial interests. The large round bales in this photograph have been mechanically gathered, rolled, and bound with cord. (Courtesy of Canton Historical Society.)

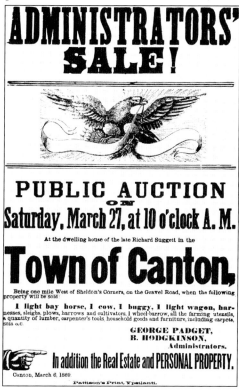

CANTON FARM AUCTION, 1869. Original Canton pioneers, Richard and Elizabeth Suggitt, who had purchased 80 acres of virgin Canton farmland in 1831, both passed away in 1868—Elizabeth on April 23rd and Richard on October 24th. A few months after Richard's death, the Suggitt farm and personal property were sold at public auction. (Courtesy of the Padget family.)

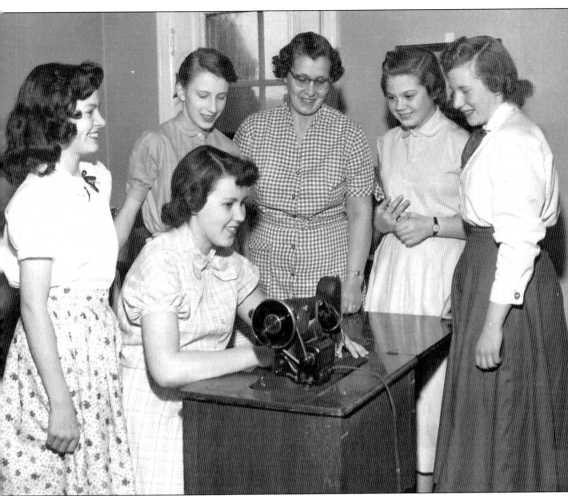

CANTON 4-H CLUB, 1950. Barbara Jean Hauk, sitting, demonstrates for the girls in her club the proper operation of a sewing machine. Standing from left to right are Colleen Dennis, Carol Tomczyk, Lenora Hauk (Barbara Jean's mother and leader of the club), Kathy Kops, and Barbara Decker. The girls are wearing the skirts that they made. (Courtesy of Canton Historical Society.)

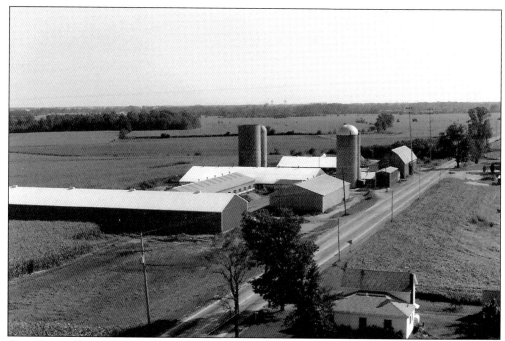

GILL DAIRY FARM. For six generations of dairy farmers, the Gill Centennial Farm was more than home—it was a way of life. Dating back to 1883, the Gill family farm, encompassing several hundred acres, straddled two county lines on the western outskirts of Canton Township. (Courtesy of the Gill family.)

GILL DAIRY FARM, END OF AN ERA. As recently as 1996, the Gill family farm produced 5,300 pounds of milk a day and tons of feed grain. Urbanization of agricultural land, not to mention strict state and federal regulations and higher taxes, made Tom Gill's decision to sell the farm in 1997 inevitable. (Courtesy of the Gill family.)

MILKING MACHINES. In this 1951 photograph, Warren (left), Russ (center), and Dick Palmer gather milking machines from a storage shed on the way to the barn where milk will be collected from several of the dairy herd. (Courtesy of the Palmer family.)

CLEARING LAND FOR NEW CONSTRUCTION, c. 1940. As late as 1940, virgin timber was being cleared in Canton to make way for new development. Pictured here is acreage on the north side of Warren Road for the new Sunflower housing subdivision. (Courtesy of Canton Historical Society.)

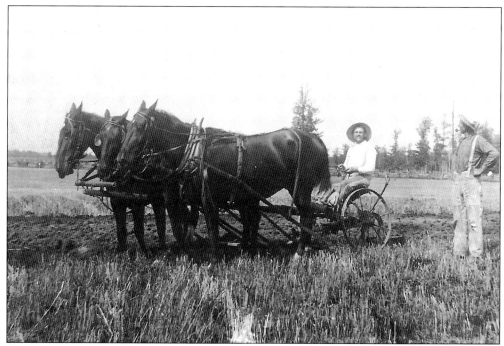

ROBERT HUTTON AND FRANK TILLOTSON, C. 1915. Frank Tillotson (right) observes Robert Hutton with three horses pulling a plow on the Tillotson farm located at the northeast corner of Sheldon and Warren Roads. (Courtesy of Canton Historical Society.)

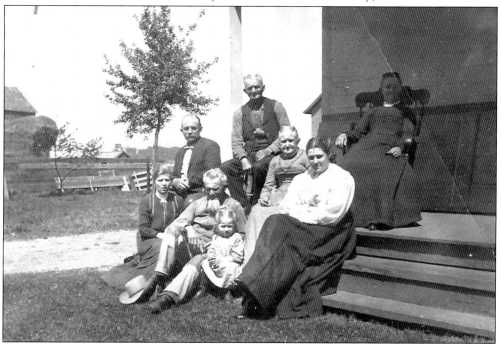

THE TILLOTSON HOUSEHOLD, c. 1905. From left to right are (first row) Louise Hutton, Frank Tillotson, Blanche Hutton, and a worker; (second row) Robert Hutton and Marian Tillotson; (third row) Burt Tillotson and Emily Tillotson. (Courtesy of Canton Historical Society.)

"THE SWEET CORN CAPITAL OF MICHIGAN." With the advent of motorized transportation in the early 20th century, Canton farming took a dramatic turn from general to specialized agriculture. From 1920 to 1970, Canton became well known in southeastern Michigan for its corn production, as well as for wheat and milk and other dairy products. While much of the production went directly to Detroit's Eastern Market, where produce could be purchased directly from the farmers, some chain stores like A&P and C. F. Smith's arranged for Canton produce to be delivered to their warehouses.

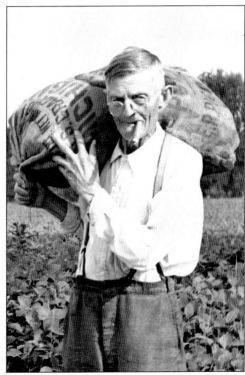

FRED PALMER, c. 1930. Carrying a burlap sack of homegrown sweet corn and smoking his trademark cigar, Fred Palmer operated a large farm on Beck and Ford Roads, where his grandparents, Aaron and Fannie Marie, originally settled the land. (Courtesy of the Palmer family.)

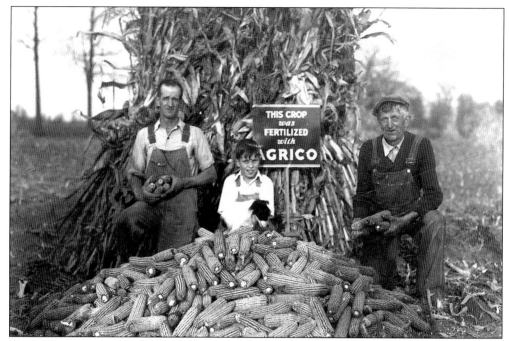

THREE GENERATIONS OF GRUMMELS. Shown here from left to right are Spencer Grummel Sr., Spencer Jr., and Joseph Grummel. Like many Canton farmers in the 20th century, "corn was king," and this important cash crop moved farming in Canton beyond subsistence to a major business enterprise. (Courtesy of the Grummel family.)

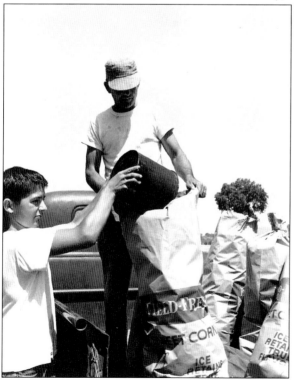

KEEPING SWEET CORN COOL, 1956. High school student Bob White drops a bucket of ice into a bag that holds 63 ears of corn. Russ Palmer holds the bag in position. Picking the corn very early in the morning and then icing it down helped to insure freshness and quality. (Courtesy of the Palmer family.)

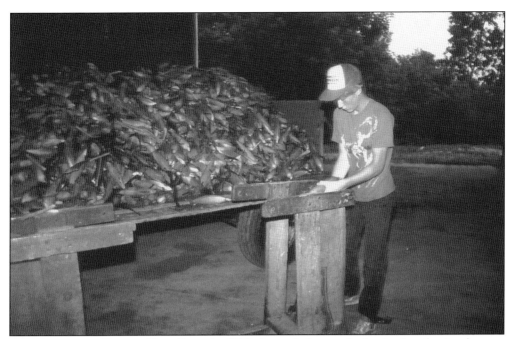

FIVE DOZEN IN A BURLAP BAG. From the 1920s forward, the standard unit of production for corn was five dozen ears to a bag, originally burlap but eventually thick paper. Bags were then driven to Detroit's Eastern Market where stalls were available on a first come basis until 1912. Afterward farmers were allowed to rent a numbered stall. (Courtesy of Canton Historical Society.)

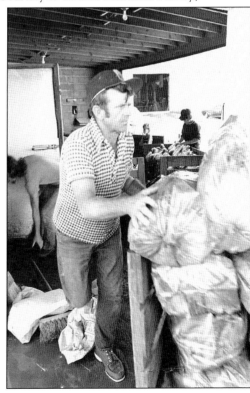

DICK PALMER, LOADING CORN FOR MARKET, 1975. Fifth generation Canton farmer Dick Palmer loads bagged corn into crates destined for the giant Kroger warehouse in Livonia. The Palmer family sold corn to Kroger stores for over 50 years, beginning in 1930 when Dick was only a toddler. (Courtesy of the Palmer family.)

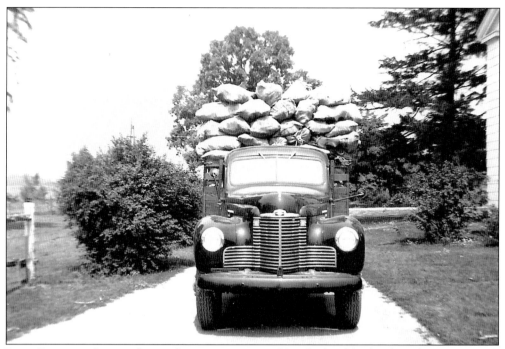

LAST LOAD OF SWEET CORN, SEPTEMBER 1949. Hundreds of burlap bags brimming with end-of-season sweet corn have been loaded onto a Palmer truck for delivery to one of several markets in metropolitan Detroit. (Courtesy of the Palmer family.)

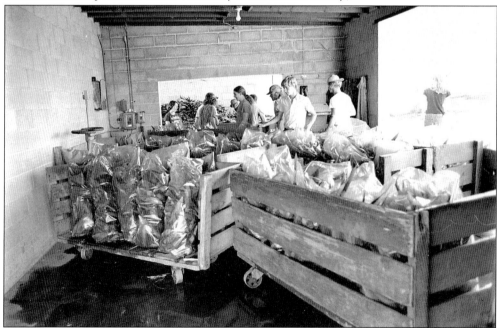

CRATING CORN FOR MARKET, 1970. Many Canton farmers were doing a very solid, specialized business in sweet corn production. Burlap eventually gave way to plastic and paper. In this picture, which was taken in a storage shed on the Warren Palmer farm, corn is being readied for delivery to Kroger Supermarkets. (Courtesy of the Palmer family.)

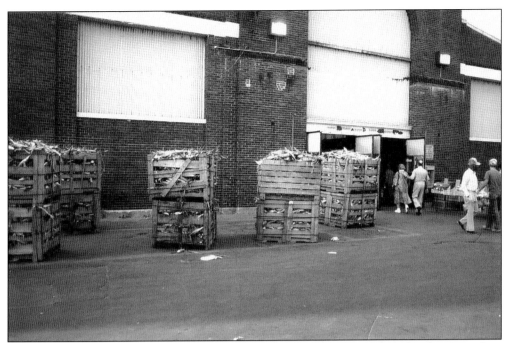

EASTERN MARKET CORN DELIVERY, 1970. Canton corn was king not only for local supermarkets but the huge Eastern Market complex in downtown Detroit. Many Canton farmers shipped crate loads of corn and rented stalls at the market for direct retail sale of their farm products on busy weekends. (Courtesy of Canton Historical Society.)

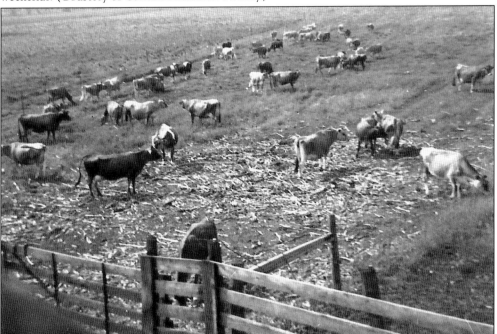

CATTLE FARMING IN CANTON. Although Canton agriculture solidified its reputation for much of the 20th century with its sweet corn production, Canton farms were by all means diversified. Pictured is a dairy herd on the Palmer farm around 1949. (Courtesy of Canton Historical Society.)

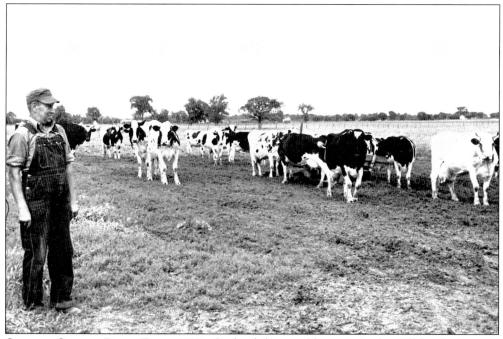

GORDON GILL ON DAIRY FARM, 1952. On land that would remain in the Gill family for more than 100 years, Gordon Gill, oldest son of George and Grace Gill, surveys his Holstein herd near Ridge Road. (Courtesy of the Gill family.)

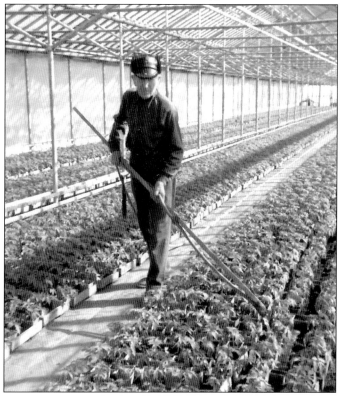

GREENHOUSE TOMATOES. In one of several greenhouses on the Fischer farm, just south of Sheldon Corners on Sheldon Road, Clarence Fischer waters tomato plants one by one. Most of the tomatoes will be marketed directly to the consumer at the Eastern and Western Markets. (Courtesy of the Fischer family.)

CLARENCE FISCHER INSPECTING TOMATO PLANTS. Second and third generation Canton farms were nothing if not diversified. On the Fischer farm, general farming included dairy cattle ranching, a variety of farm produce, including sweet corn, was grown, and there was an extensive network of greenhouses in which several varieties of tomatoes were cultivated. (Courtesy of the Fischer family.)

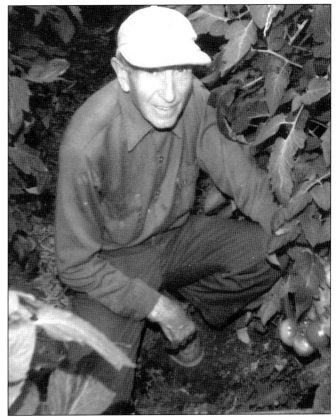

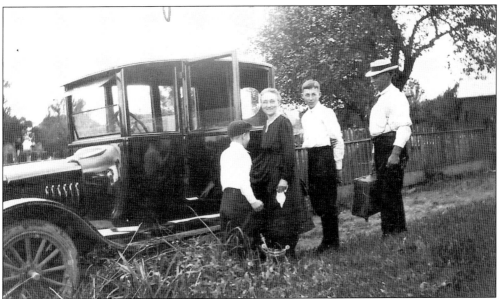

EDITH MOYER (NÉE SAYLES) TAKES AN OVERNIGHT TRIP, SEPTEMBER 5, 1921. Husband Elam and sons Howard and Ralph say goodbye to their mother as she prepares to depart for an overnight visit. By 1920, 40 percent of Michigan's farms had automobiles, and by 1930, nearly 20 percent of township farmers had purchased trucks (Courtesy of Canton Historical Society.)

LILLEY ROAD, 1918. Looking south from Joy Road, Lilley Road, particularly during bad weather, was treacherous for either automobile or horse and carriage. Note the wood planks alongside the roadway, which served as pedestrian walkways (Courtesy of the Mettetal family.)

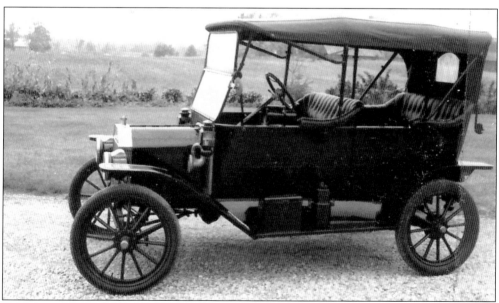

HOWARD SALLEY'S 1914 FORD TOURING CAR. This classic automobile was owned by Howard Salley and Gladys Salley (née Palmer). Howard and Gladys lived in Canton on property at the southeast corner of Ford and Beck Roads for almost 50 years. They moved to Plymouth shortly before their golden wedding anniversary. (Courtesy of Canton Historical Society.)

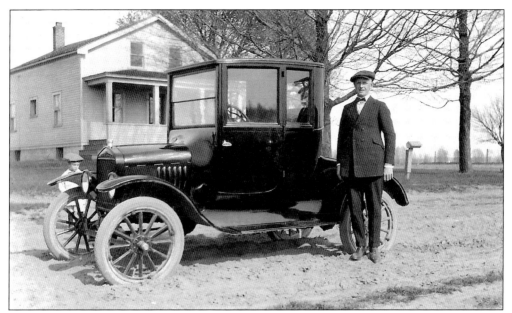

RAPHAEL "RAY" METTETAL, PROUD NEW MODEL T OWNER. Not long after moving from Redford to Canton, Ray Mettetal purchased his first Model T. In this picture, he prepares to give the car a good road test on Lilley Road. (Courtesy of the Mettetal family.)

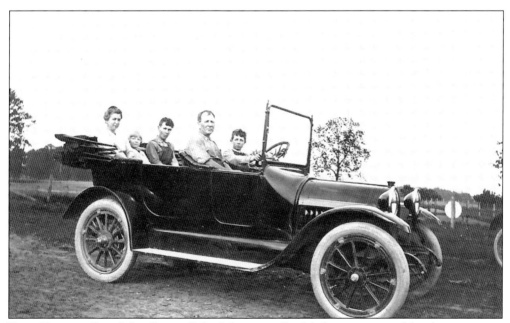

FIRST FISCHER CAR. John George Fisher's first car, a Studebaker, was a proud family acquisition. Sitting in the back seat, from left to right, are Edna (mother), Edna (daughter), and John; in the front seat, from left to right, are John and Clarence. (Courtesy of the Fischer family.)

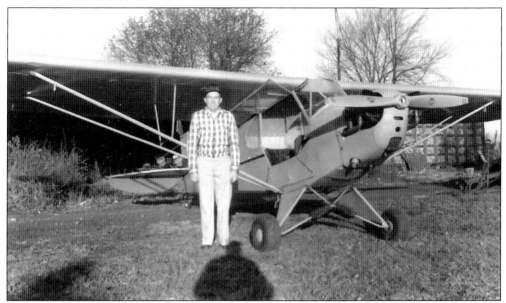

CLARENCE FISCHER WITH AIRCRAFT. The Fischer farm, located on both sides of Sheldon Road, included a dirt airstrip for Fischer family aircraft. Pictured is Clarence Fischer standing next to his Piper J3 Cub, built in 1946. The Fischer corncrib can be seen on the right in the background. (Courtesy of the Fischer family.)

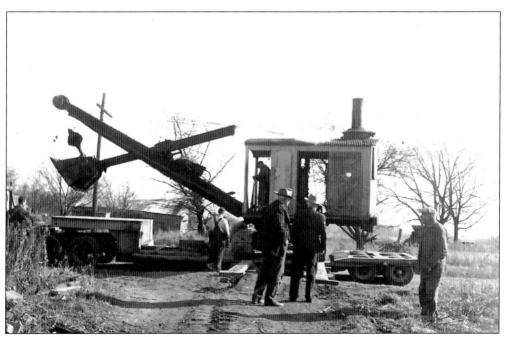

FISCHER STEAM SHOVEL. John George Fischer had obtained a steam shovel to conduct excavations on his Sheldon Road farm. John S. Haggerty learned that Fischer possessed such an industrial machine and negotiated the purchase for his brick business in Springwells. The steam shovel is pictured here as it is being loaded onto a hauler for transfer. (Courtesy of the Fischer family.)

Four

BUSINESS
AND COMMERCE

Until approximately 1970, Canton's primary industry was agriculture; after 1970, it was residential construction. At Sheldon Corners and Cherry Hill, the two villages that sprang up as community centers early in Canton's history, a variety of shopkeepers and merchants provided services to the growing farming population. Each village was anchored by a general store, a church, a post office, a blacksmith, a creamery, and assorted other small commercial establishments. In both villages, the general store was more than simply the purveyor of goods and services. It was a true community center where farm families exchanged news, gossip, and practical information. At Sheldon Corners, this was the Winsor Store; at Cherry Hill, it was the Cherry Hill Inn.

A number of businesses supporting the agricultural industry developed in Canton Township. Gristmills, like Penney's on Joy Road, ground grain into flour and corn meal for human consumption and various grains for livestock feed. Feed stores, like Hewer's on Canton Center Road, and lumber and sawmills provided specialized products and services.

As the population grew, and residential construction tipped the balance, a number of major retail outlets began to replace homesteads at key highway intersections. National retail chains such as Wal-Mart, Sam's Club, Home Depot, Lowe's, Kohl's, Target, and Ikea have located in Canton during the last decade.

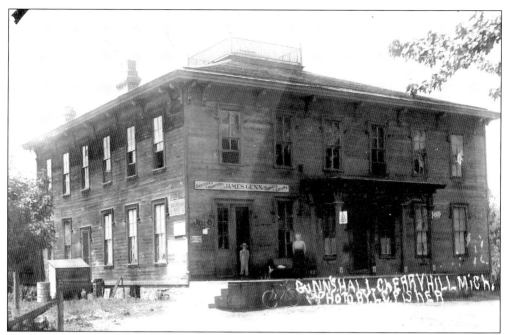

GUNN'S HALL, REFURBISHED. As part of his continuing renovation of the former Cherry Hill House, James Gunn built a new front porch and entrance facade on the right-hand side of the building. Inside on the second floor, Chris Abelson agreed to install a maple dance floor in exchange for two years worth of free dance passes for him and his sister. (Courtesy of Canton Historical Society.)

⚞CLOSING ∗ MASQUERADE ∗ PARTY⚟

Will be given by the S. G. C. B. at

CHERRY HILL HALL,

FRIDAY ∗ EVENING, ∗ APRIL ∗ 12, ∗ 1889.

YOURSELF AND LADIES RESPECTFULLY INVITED.

⚞AMERHINE AND LEMEN'S ORCHESTRA.⚟

Bill, Fifty Cents. Basket Picnic Supper.

BAGGAGE CHECKED AND HORSES STABLED.

MASQUERADE PARTY ANNOUNCEMENT. Following his purchase of the Cherry Hill Inn in 1884, James Gunn refurbished and converted the second floor of the inn to an enormous dance hall. A year before the masquerade party that is promoted in this poster, a new maple floor was installed by Chris Abelson. (Courtesy of Canton Historical Society.)

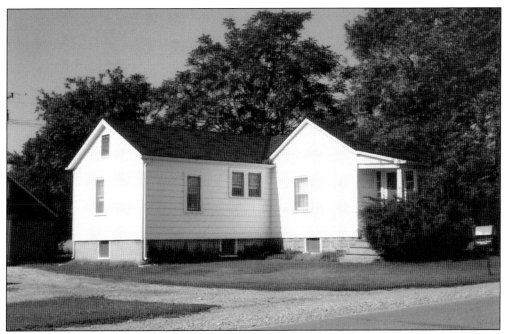

ORIGINAL WEST STORE ON CHERRY HILL ROAD. Shortly after his move from Detroit in 1901, William Henry West opened this unassuming general store and post office on Cherry Hill Road, just east of Ridge Road and Gunn's Hall, which he would eventually purchase. He served here as village postmaster for five years.

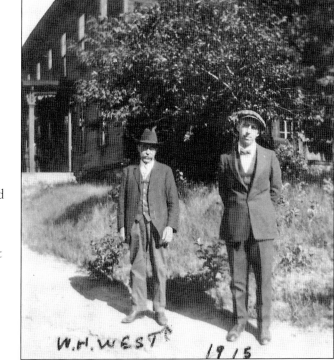

WILLIAM HENRY WEST AND MR. YOST. After having worked as a conductor on horse-drawn streetcars in Detroit and as a small-store owner on Cherry Hill Road, William Henry West (pictured with an associate) was ready for bigger things. The photograph, from 1915, was taken just a couple of years before he purchased the former Hitchcock building. (Courtesy of Canton Historical Society.)

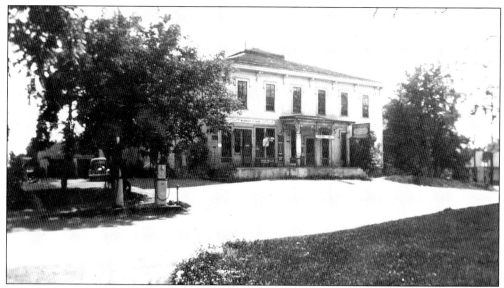

WEST GENERAL STORE. In 1919, William Henry West purchased Gunn's Hall and moved his general store from its former location two houses down the street to the new site. Dances continued to be held upstairs, which was also used for Grange and other meetings, up until the time of World War II. The construction of Willow Run and a shortage of housing during the war years led to the subsequent division of the old dance floor area into four apartments. (Courtesy of Canton Historical Society.)

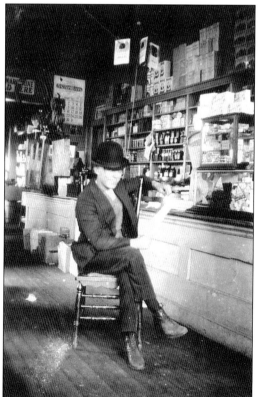

JAKE WEST, 1920. Arthur Jerome West, better known to his friends and customers at the West General Store simply as "Jake," was the fourth child of William H. and Louisa West. Jake was the only one of his siblings to follow his father as general store proprietor. He continued to run the business his father established until 1968 when he sold the building and moved to Florida. (Courtesy of Canton Historical Society.)

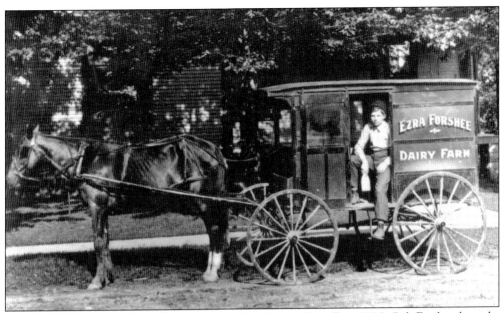

FORSHEE DAIRY BUSINESS. After marrying Mary Louise Powell in 1906, Cub Forshee brought his wife to the family farm where they parented five children. While Cub and Mary operated the Maple Lawn Dairy, brother Eliza owned and operated the Eliza Forshee Dairy. Pictured above is one of his horse-drawn milk wagons in 1900, from which bottled milk was delivered locally. (Courtesy of Canton Historical Society.)

CHEESE FACTORY. Located just south of the Boldman house but on the same property, the cheese barn is significant in the agricultural history of Canton Township. The 1860 agricultural schedule of the census showed that David Boldman owned four milch cows (milk producing) and made 400 pounds of butter and 200 pounds of cheese. By 1990, the barn had deteriorated so much that it had to be demolished. (Courtesy of Canton Historic District Commission and Michael Fitzgerald.)

HENRY FORD VILLAGE INDUSTRY. In 1944, Henry Ford opened this small factory on the corner of Cherry Hill and Ridge Roads. The factory served as one of his "village industries," where Ford employed disabled war veterans from various veterans' administration hospitals. The veterans manufactured automobile parts, including radiator petcocks and door locks. The two-story, concrete-block building, covered with stucco, originally had 3,100 square feet of workspace on the first floor and over 2,000 square feet of workspace on the lower level. The ceiling had been made of wood from one of Ford's Upper Peninsula sawmills, which also produced the wood for the "Woody" station wagons.

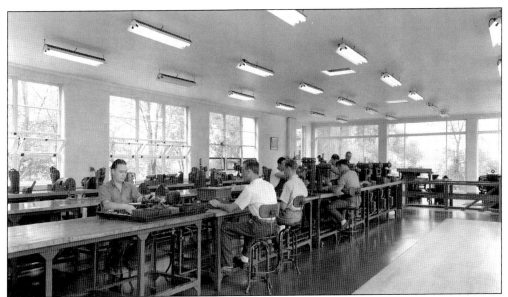

HENRY FORD VILLAGE INDUSTRY, INTERIOR. The Ford Cherry Hill plant began operations in July 1944 and served at least two purposes, to provide training and rehabilitation for returning war veterans, as pictured here, and to supplement work at the Willow Run Bomber Plant, which was experiencing labor shortages. Two trade instructors were sent from the bomber plant to manage the work at the 5,400-square-foot factory. (Courtesy of the Henry Ford.)

CHERRY HILL CREAMERY, MOVED BY HENRY FORD. From 1900 until the advent of the Second World War, the Cherry Hill Creamery, located on South Ridge Road near Cherry Hill Road, was a successful local business in Cherry Hill Village. In 1943, Henry Ford purchased the property and moved it south on Ridge Road where it would become a residence hall for more than a dozen veterans working in the Cherry Hill Ford Factory. (Courtesy of Canton Historical Society.)

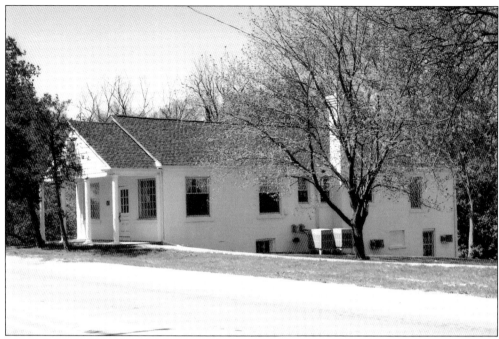

WORLD WAR II VETERAN'S DORMITORY. Situated directly south of the Henry Ford village factory on Ridge Road is the residence hall that housed 18 to 20 war veterans. The arrangement was unique among the Ford Village Industries in that war veterans, rather than off-season local farmers, were employed to produce parts for Ford's various assembly plants. The building was originally a creamery that had served the Cherry Hill community in prior years and was moved by Ford to its present location from the site of the factory.

MARCEL DUTHOO'S FEED GRINDING BUSINESS. For much of the 1930s and 1940s, Marcel Duthoo operated a mobile feed-grinding business from the back of his truck. Duthoo would shovel the farmer's whole grain into the hopper, grind it to the farmer's specifications, and then supply the fine feed for cattle and chickens. Among Duthoo's regular route customers were well known Canton farmers, such as the Cortes, the Schultzes, and the Hauks. (Courtesy of Marie Gentz.)

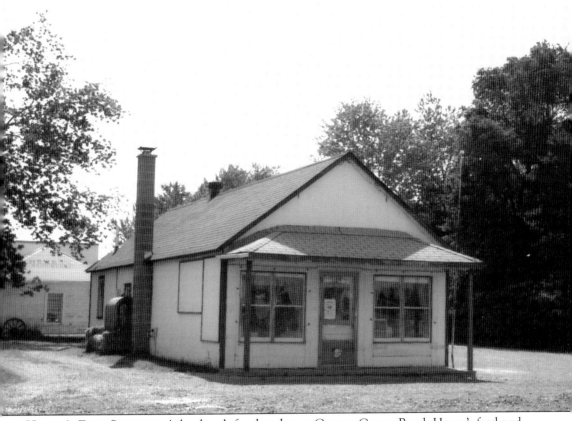

HEWER'S FEED SUPPLIES. A landmark for decades on Canton Center Road, Hewer's feed and grain store was operated by Charles and Mildred Hewer, who moved to Canton from Detroit's east side after World War I. Although he farmed five acres and raised prize-winning poultry, Hewer sold feed to meet expenses. In 1940, he opened up shop across from what is today Canton High School. Ralph Burch purchased the feed store in 1976, before Charles passed away that same year, and Ralph's three nieces—Catherine, Rita, and Mary—continued operating the business under a new name, the Country Place. (Courtesy of Canton Historic District Commission and Michael Fitzgerald.)

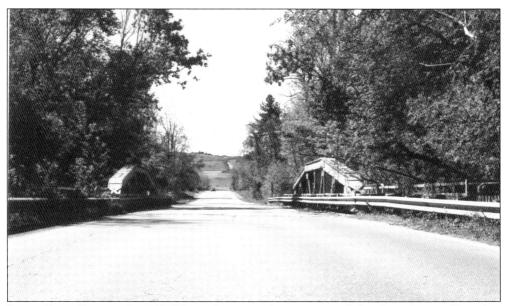

Lilley Road Bridge. In 1933, Wayne County took over responsibility from Canton Township for the dilapidated steel bridge that crossed the main channel of the Lower Rouge River at Lilley Road. The bridge, originally fabricated in 1923 by the Massillon Bridge Company in Ohio, was removed by the road commission from the Telegraph Road crossing of a branch of the Rouge River in Detroit. It was moved to Lilley Road. The widening of Telegraph Road rendered the bridge no longer suitable for its original location.

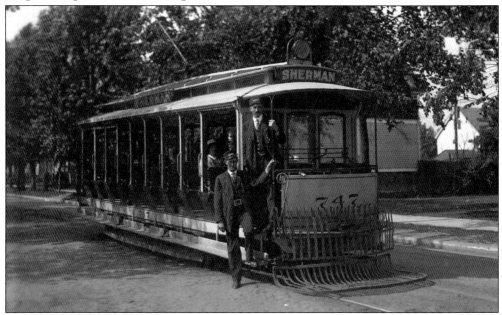

Interurban. At the beginning of the 20th century, local transportation in Canton and environs was severely limited by the poor condition of its roadways. Prior to the advent of the automobile, a cheap and convenient alternative arose—the interurban, a streetcar line that connected Canton to Detroit, to Ypsilanti, to Ann Arbor, to Saline and, eventually, pushing further west, all the way to Chicago. (Courtesy of Canton Historical Society.)

FIRST MILE OF PAVEMENT IN CANTON, c. 1918. Canton's major thoroughfare, U.S. 12, or Michigan Avenue, is now open for east-west automobile traffic. Also known as the "Chicago Road," Michigan Avenue roughly followed the old Saulk Trail, an American Indian footpath that traversed the state of Michigan from downtown Detroit to Chicago. (Courtesy of Canton Historical Society.)

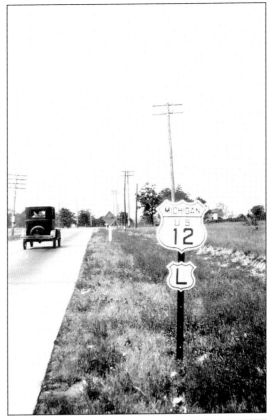

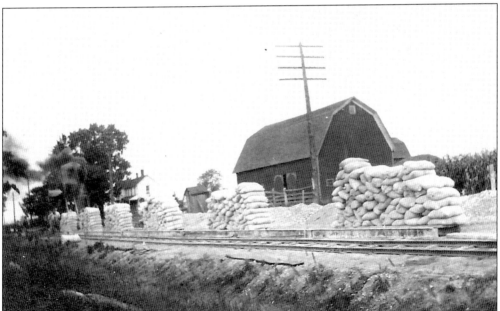

CHERRY HILL ROAD CONSTRUCTION, c. 1920. Cherry Hill Road was a dirt road for more than 50 years until major concrete road construction began in earnest in Canton around 1920. The Dicks farmhouse can be seen on the left in the background. (Courtesy of Canton Historical Society.)

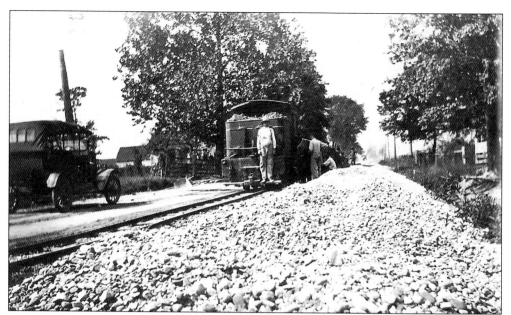

ROAD CONSTRUCTION TECHNOLOGY. In front of the Coles farm on Cherry Hill Road, west of Canton Center, bags of Portland cement are stacked along the temporary railroad line established to transport materials. The road would be built as a convex surface so that water will drain into the ditches. (Courtesy of Canton Historical Society).

FUNK GENERAL STORE. Alice Funk, a student at Canton Center School, poses in front of the Funk General Store, operated by her parents from 1928 through 1937 and located on the corner of Canton Center and Cherry Hill Roads. Prior to the Funks operating the store, the building had served as the first Dennis store, which subsequently moved north of Ford Road, on the east side of Canton Center Road. (Courtesy of Canton Historical Society.)

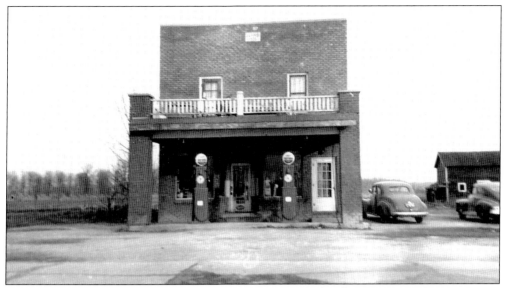

SECOND DENNIS MARKET. In 1928, Colburn Dennis Sr. built a larger store on Canton Center Road north of Ford Road. During the Depression it was not unusual for Colburn to accept farm products, such as homemade butter, eggs, and poultry in exchange for store goods. In May 1945, Colburn Dennis Jr., better known as "Cobe" to his friends and customers, took over his father's grocery business. (Courtesy of Conrad Dennis.)

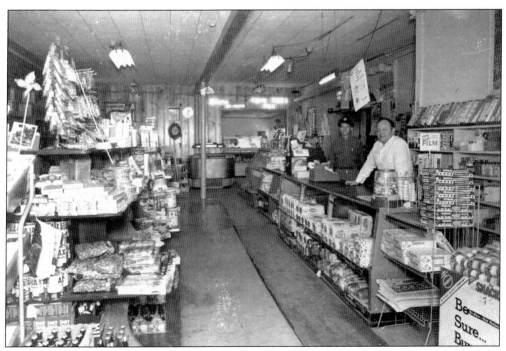

DENNIS MARKET, 1953. In this interior picture of Dennis Market, Cobe Dennis Jr., is behind the counter. Behind him is Jesse Booker Jr., better known as "Junior," who worked for the Dennises until his death in the mid-1980s. (Courtesy of Conrad Dennis.)

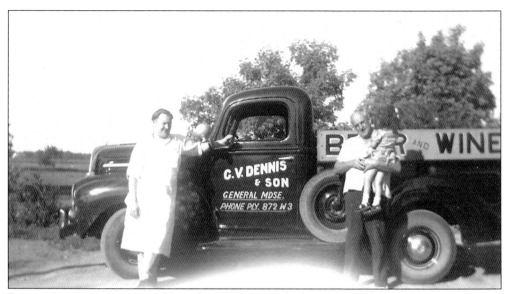

DENNIS DELIVERY TRUCK. In this mid-1940s photograph, three generations of Dennises—Cobe Sr. (holding granddaughter Colleen), and Cobe Jr.—pose in front of the market's truck, which was used exclusively for grocery deliveries to customers. (Courtesy of Conrad Dennis.)

TRAILERS TO RENT. By offering a full line of groceries, gasoline, and even trailers, as pictured at left, the Dennis Market was truly a "full service" store for the Canton community. (Courtesy of Conrad Dennis.)

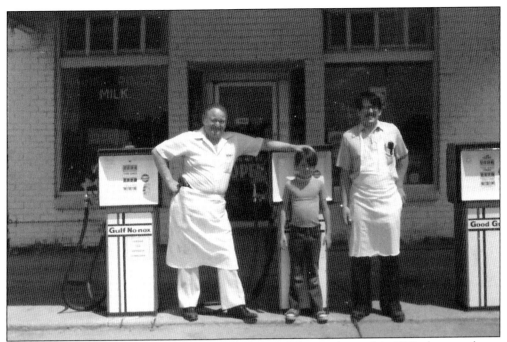

THREE GENERATIONS OF DENNISES. Standing from left to right in this 1977 photograph are Colburn "Cobe" Dennis Jr., Colburn "Cole" Dennis IV, and Colburn "Butch" Dennis III. Cobe Dennis operated the store 16 hours a day, 7 days a week, 52 weeks a year, including Christmas and holidays, for more than 25 years. (Courtesy of Stephanie Dennis.)

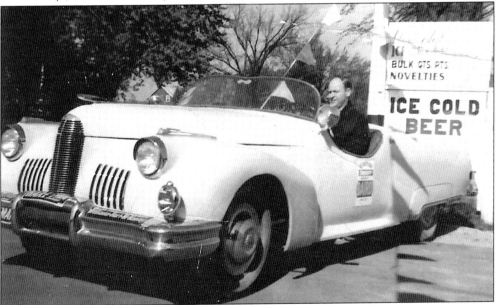

COBE'S HOT ROD. In the early 1950s, Cobe Dennis Jr. decided he needed a hobby to provide him with some relaxation. He decided to build a hot rod from parts taken from a 1940 LaSalle, a 1953 Cadillac, an early 1950s Oldsmobile Rocket 88, and a Kaiser Fraser. The final product was enjoyed by the entire Dennis family and became the store's unofficial trademark. (Courtesy of Conrad Dennis.)

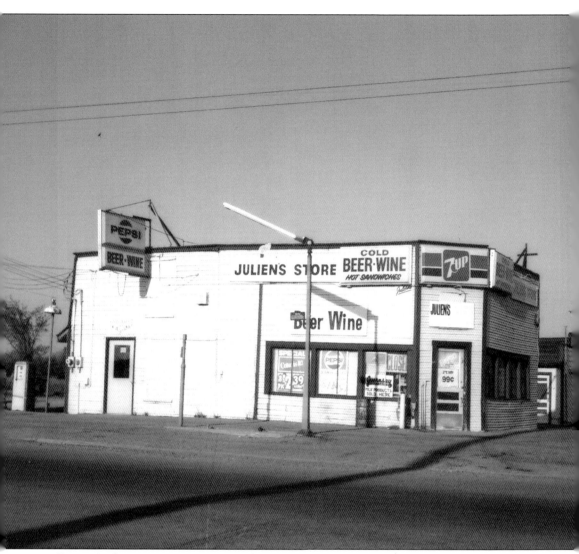

JULIEN'S CORNER MARKET AND GAS STATION. Investing $800 in 1944 to purchase a three-quarter-acre plot on the southwest corner of Ford and Canton Center Roads, James Julien created a community corner, popular with both children and adults. Typically Julien's opened at 5:30 a.m. and did not close until nightfall. Julien's was demolished in 2001 and replaced by a Rite-Aid Pharmacy. (Courtesy of Canton Historic District Commission and Michael Fitzgerald.)

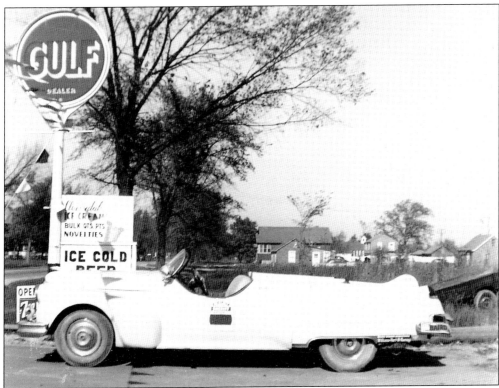

DENNIS MARKET TRADEMARK. Having built his hot rod in the storeroom of the Dennis market, Cobe asked his longtime friend Roy "Skippy" Henry to provide the finishing touch to his automotive creation by painting the vehicle a bright yellow. The final product became a popular conversation piece for old and new customers alike. (Courtesy of Conrad Dennis.)

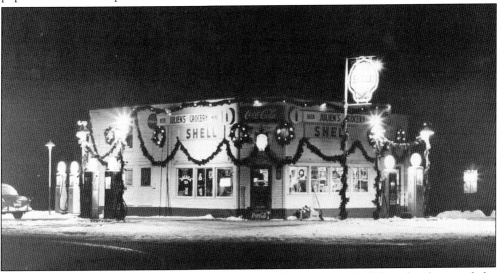

JULIEN'S GROCERY, CHRISTMASTIME. For nearly half a century, the Julien family served the Ford Road and Canton Center community with grocery goods and roadside services. Christmas was a special opportunity for the Juliens to thank the community for its patronage by adorning their market with festive decorations. (Courtesy of Canton Historical Society.)

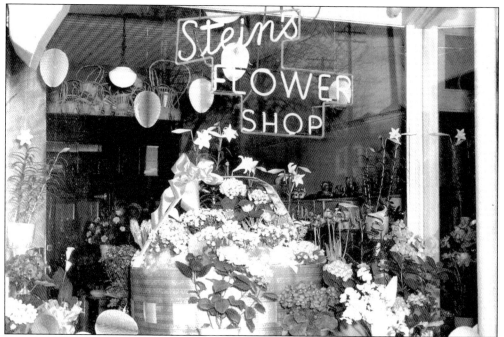

STEIN'S FLOWER SHOP, 1950. Son of Peter Stein and Emma Stein (née Dingeldey), who were early settlers in Sheldon Corners, Howard Stein opened a greenhouse on the north side of the Chicago Road (Michigan Avenue) in 1922. His fresh flowers, cultivated in an expanded greenhouse of 44,000 square feet, were much in demand, and his family business continued to provide floral arrangements for weddings, funerals, and holidays for the next 62 years, until the business was sold in 1984 to the Kellers and renamed Keller and Stein, a business that continues to serve the community to the present day. (Courtesy of Clark Keller.)

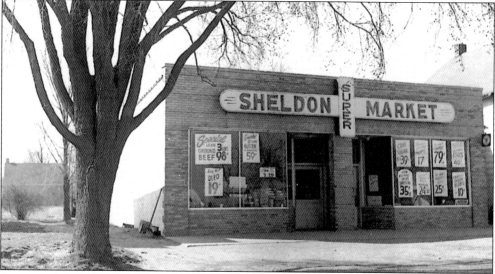

SHELDON SUPERMARKET. On the southeast corner of Michigan Avenue and Sheldon Road, the Sheldon Supermarket served the community of Sheldon Corners for more than two decades beginning in the late 1940s. The market was built of concrete blocks by John Fischer and was managed by John Galligay. (Courtesy of Canton Historical Society.)

Five

HISTORIC HOMESTEADS

The first homes in Canton Township were either one-room log cabins or two- (or more) room log houses. While no such log homes have survived today, a few existing homes, such as the David Boldman house on Canton Center Road and the Patterson-Gilmore house on Ridge Road, show evidence of log construction in their foundation.

Over time log homes would be replaced by more refined frame houses. The architectural style of these homes varied considerably, but a common thread was that very few were high style or ornate. Within an agricultural context, these homes were relatively modest. A number of surveys of historical structures within Canton Township have identified the following architectural styles: Queen Anne, Greek Revival, four square, Tudor Revival, Colonial Revival, Cape Cod Revival, and bungalow style. These styles are reflected in the homes pictured in this chapter. Sadly the majority of these homes have been demolished.

During the residential building boom after 1970, these second generation homesteads were replaced by subdivision homes, and modern retail outlets sprang up in the form of neighborhood strip malls.

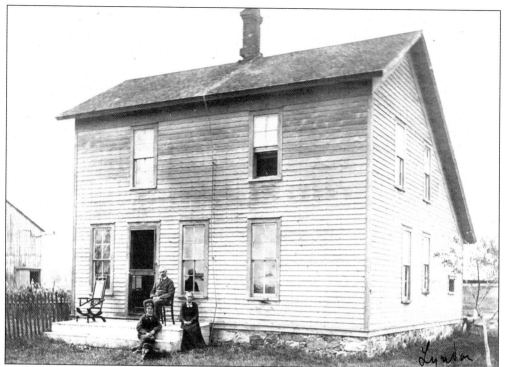

SMYE HOUSE. Following a fire that completely gutted her Canton Center Road log cabin, Arline Harmon, Truesdell School's first teacher, built a new house on the same spot with her husband Ben Conner. After Conner passed away, Arline married Titus Smye, with whom she had two children, John Earl and Edna May. Pictured on the front porch are John Earl, Titus, and Arline. (Courtesy of Canton Historical Society.)

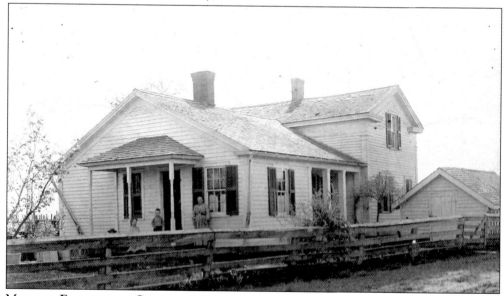

MICHAEL FISCHER AND CATHERINE FISCHER (NÉE HASSELBACH) HOME. Located on Geddes Road, west of Sheldon, the Fischer residence was home to Michael, Catherine, four daughters (Julia, Anna, Ida, and Mary), and one son (John George). (Courtesy of the Fischer family.)

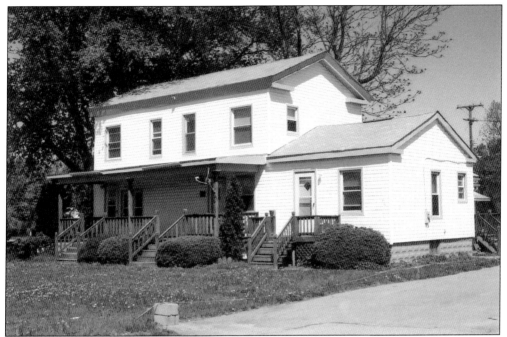

SHELDON INN. Built around 1825 by original settlers Timothy and Rachel Sheldon, the inn is of major historical significance to the region. A settlers' inn and stagecoach stop along the old Chicago Road, it became one of the main focal points of Sheldon Corners, Canton's other crossroads hamlet. At the time of its initial construction, there were virtually no comparable overnight stops as far west as the Indiana line. Today the inn serves as a two-family duplex.

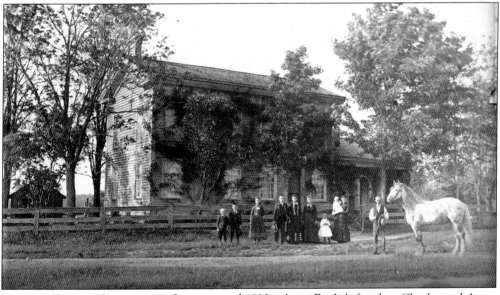

MORTON FAMILY HOME, 1890. On or around 1890, a large English family—Charles and Anne Morton and their nine children—moved into the former Sheldon Inn, the landmark lodging house on the old Chicago Road around which Sheldon Corners developed. Pictured from left to right are Mark, Edward, Lucy, Charles, Eliza, Mary, Annie, Alfred, Anne, and Charles, along with their horse Wonder. (Courtesy of Canton Historical Society.)

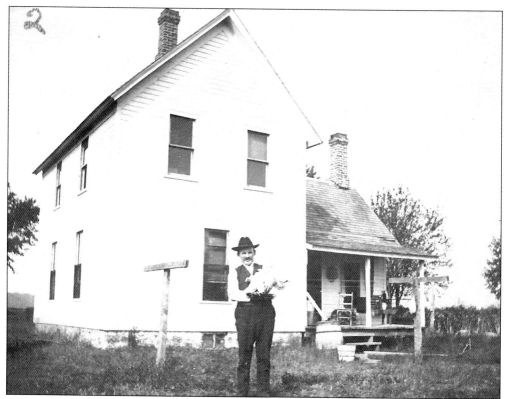

TILLOTSON HOUSE, BUILT FOR ROBERT HUTTON. In 1897, 15-year-old Robert F. Hutton arrived from Vermont to work on the Sheldon Road farm of the Tillotson brothers, John Burton and Franklin. Three years later, he married Louise Gerst, and a small house was built for them, just south of the main farmhouse, but on the Tillotson property. (Courtesy of Canton Historical Society.)

FISCHER MILK HOUSE. After marrying Edna Truesdell and purchasing a farm, John Fischer built this small house for his new bride. After completing the construction of a much larger home on the same property in 1897, the Fischers converted their former residence into a milk house. (Courtesy of the Fischer family.)

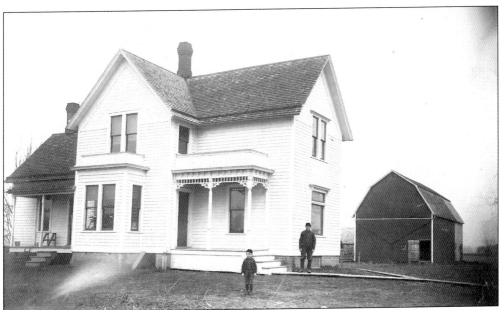

JOHN FISCHER HOMESTEAD. John and Edna Fischer, second generation settlers, raised four children—George, John, Clarence, and Edna—in their large new home on the west side of Sheldon Road, south of Michigan Avenue. (Courtesy of Canton Historical Society.)

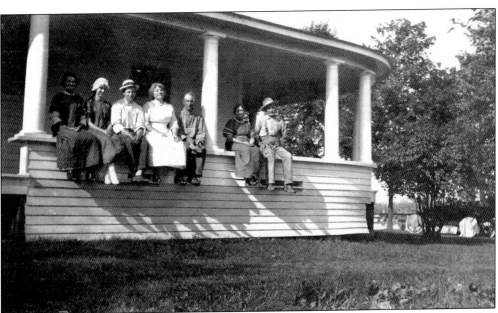

WILLIAM S. TRAVIS HOME ON CANTON CENTER ROAD. Sitting on the porch railing from left to right are Ella Rowe (née Travis), Blanche Rowe, unidentified, Emma Lamarand (née Travis), William S. Travis Jr., Martha Travis (née Cook), and William S. Travis Sr. (Courtesy of Canton Historical Society.).

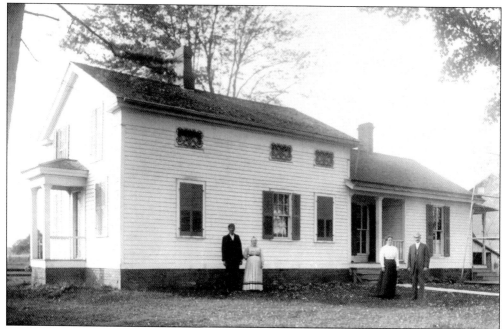

LOHR-LOTZ FARMHOUSE. The Charles Lohr family farm was located on the south side of Michigan Avenue, just west of Lotz Road. George Lotz and Sarah Lotz (née Hasselbach), the couple on the left in the picture above, purchased the farm from the Lohrs some time after 1900. The two individuals on the right are unidentified. (Courtesy of Canton Historical Society.)

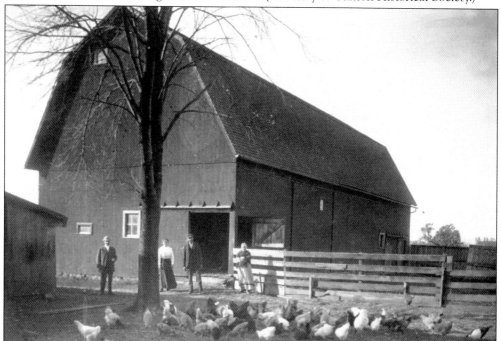

LOHR-LOTZ BARN. At the time the George Lotzes, the couple pictured on the right, purchased the Lohr farm, it straddled both sides of Lotz Road and included a saw- and gristmill. The two on the left remain unidentified. (Courtesy of Canton Historical Society.)

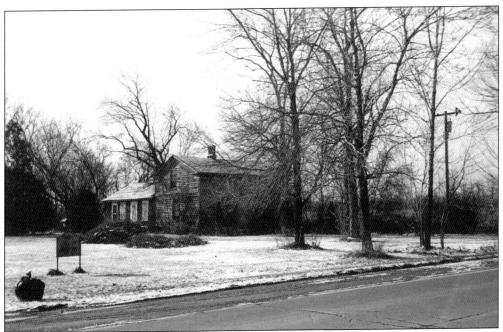

PADGET CENTENNIAL FARM. The Padget family lived at 48185 Geddes Road for over 100 years, qualifying this property for the official centennial farm designation. Seven generations of Padgets have lived in Canton Township, variously raising corn, wheat, potatoes, and dairy cows. (Courtesy of Canton Historical Society.)

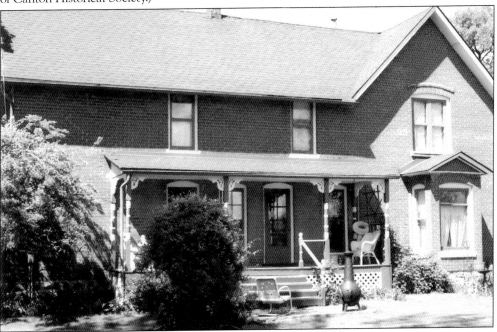

SMITH HOUSE. Located just north of the intersection of Michigan Avenue and Sheldon Road (the area known formerly as Sheldon Corners), this house is an excellent example of a brick, vernacular, *L*-shaped domicile with Victorian details. Built in 1904 by George Smith Jr., the house replaced the previous log home that both his father and grandfather had resided in.

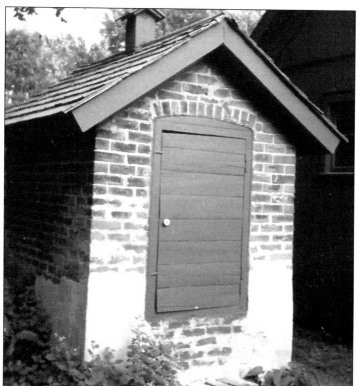

SMITH SMOKEHOUSE. The small brick and concrete smokehouse, with gable roof, was built of homemade bricks in the 1830s by early settler William Smith. The smokehouse is located behind the house, south of the garage.

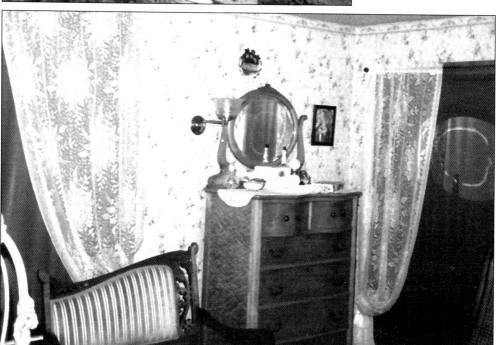

FRONT BEDROOM, SMITH HOUSE. Ruby Jane Smith, eldest daughter of George Smith Jr. and Mary Smith, lived with her husband Edward Glaesner Hoops in the brick home built by her father. The wallpaper pictured dates back to the 1930s.

SMITH GARAGE AND PRIVY. The one-and-a-half-story, gable-roofed garage has sliding doors on the east facade for vehicles. The garage was built originally as a woodshed and icehouse. Located next to the garage on the north is a board and batten-sided outhouse.

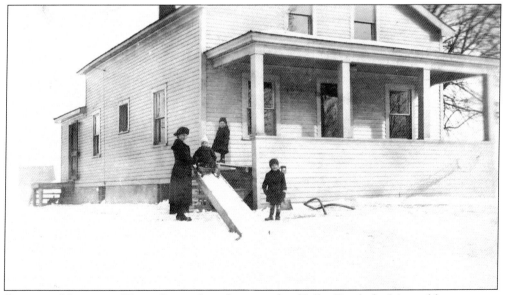

ORIGINAL METTETAL HOME. Located on the east side of Lilley Road, the Mettetal home sat on 80 acres that Ray Mettetal had purchased during the summer of 1920. Ray had moved his greenhouse from Redford and reopened his business in Canton by this time. (Courtesy of the Mettetal family.)

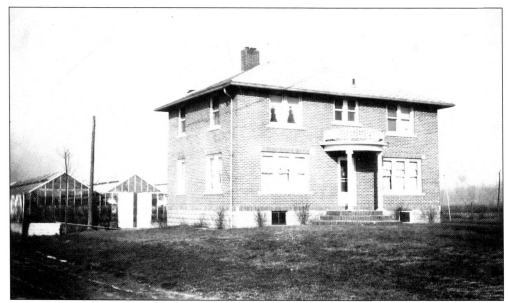

METTETAL HOME AT 8425 LILLEY ROAD. In 1924, Ray Mettetal designed and built this two-story, five-bedroom home to accommodate his growing family. Their new home was situated on 20 acres on the west side of Lilley Road. Here Ray and Stella raised 10 children together. (Courtesy of the Mettetal family.)

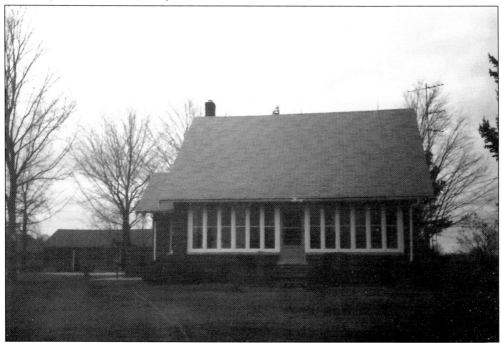

PALMER HOME, 5777 BECK ROAD. This second home was built by Fred and Odelia Palmer on the same site as their original home. The foundation of the two-story building was retained and the house was built on top of it. Construction began in 1936. Fred and Odelia lived with their daughter Gladys and son-in-law Howard Salley while the house was under construction. (Courtesy of Canton Historical Society.)

PENNEY HOUSE. Five generations of the Penney family have lived in this residence on Joy Road since Benjamin Franklin Penney constructed it in 1856. The family lived in a log cabin on the farm until their large gable front and wing house was completed. In addition to farming, Benjamin operated a blacksmith shop. The next generation of Penneys added a second floor to the blacksmith shop and converted it to a successful gristmill. (Courtesy of Canton Historical District Commission and Michael Fitzgerald.)

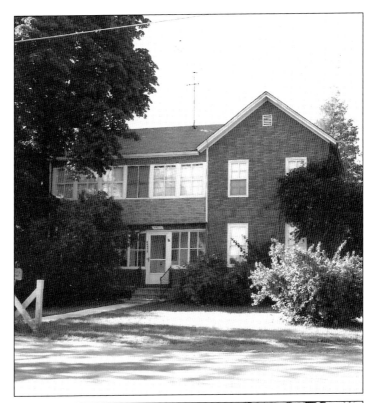

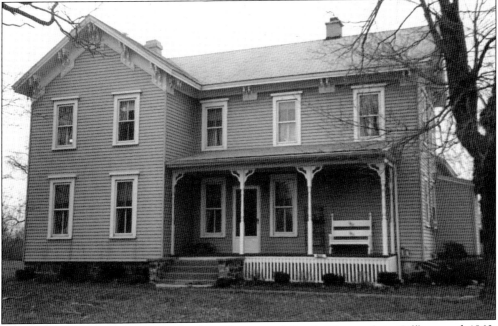

HUSTON HOMESTEAD. Built by Reuben Huston and Sarah Huston (née Gill) around 1860, this upright and wing two-story house is a Canton historic site that remained in the Huston family until the late 1930s. The house was restored by its present owners, John and Melissa McLaughlin, in 1978. (Courtesy of Canton Historical Society.)

JERSEY BELL DAIRY. Another local historic site is the Jersey Bell Dairy located at 7917 Canton Center Road, originally Greek Revival in style, some Federal-style characteristics have been accentuated during the rehabilitation of the property by the current owner occupants. The property is historically significant as a community-based dairy and was the first to deliver milk door to door in the Plymouth-Canton area. The owners of the dairy were Perry and Elsie Campbell. The dairy was formally established in 1929 when the Campbells stopped selling milk to the Detroit Creamery and began marketing the milk themselves. (Courtesy of Canton Historic District Commission and Michael Fitzgerald.)

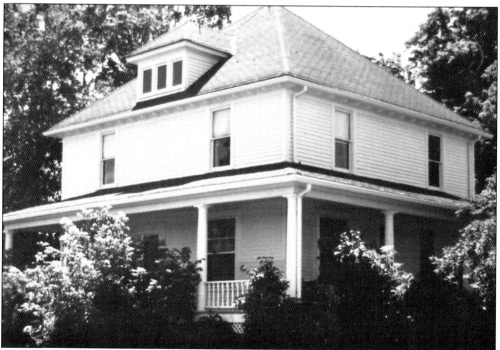

WESTFALL-KORTE HOUSE, 46601 WARREN. Built in 1914 by Ernest Westfall, this house is significant for its architecture. Its Colonial Revival details make this a much more elaborate version of a foursquare farmhouse than commonly found in the Midwest. Westfall had purchased the property for $3,225 in 1904 from Daniel Adams. In 1925, Fred and Loretta Korte purchased the home, which still had no indoor plumbing or electricity. (Courtesy of Canton Historic District Commission and Michael Fitzgerald.)

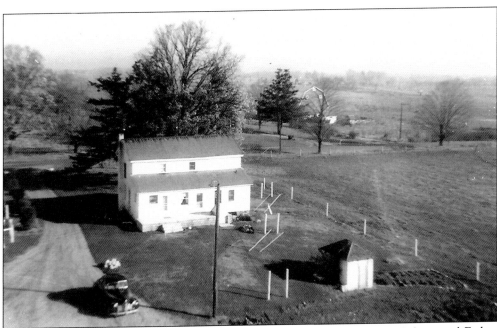

WARREN PALMER FARM, 48145 WARREN ROAD. In about 1940, Warren Palmer and Esther Palmer (née Wiseley) purchased the large home on Warren Road that had belonged to Esther's father, Allen Wisely. Following Esther's death in 1956, Warren married Alice McClumpha (née Collins) and continued to live at and farm the Wiseley property. This photograph was taken from atop a silo on the property. (Courtesy of Canton Historical Society.)

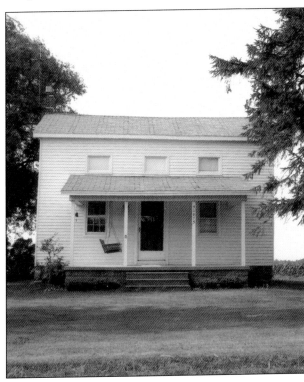

GRUMMEL FARMHOUSE, 50875 PROCTOR ROAD. Four generations of Grummels—Joseph, Spencer Sr., Spencer Jr., and David—farmed the land and raised dairy cattle on their Proctor Road farm for the better part of the 20th century. Although this particular farmhouse has long been demolished, David and Debra Grummel (today spelled Grammel) still reside on Proctor Road, just a little further east of the original Grummel farm. (Courtesy of Canton Historic District Commission and Michael Fitzgerald.)

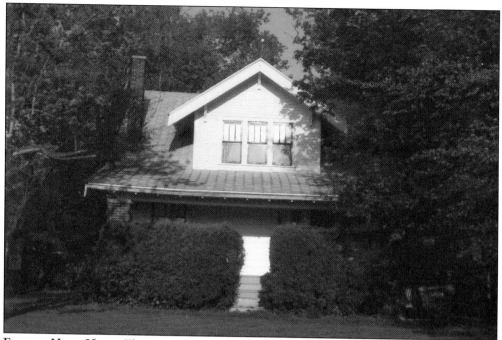

EDWARD HAUK HOME. The young married couple, Edward Hauk and Mary Hauk (née Bewermitz), built this home around 1920 on the southwest corner of Canton Center and Ford Roads. Edward grew corn, wheat, and oats on the farm and opened the first roadside produce stand on Canton Center Road. (Courtesy of Canton Historic District Commission and Michael Fitzgerald.)

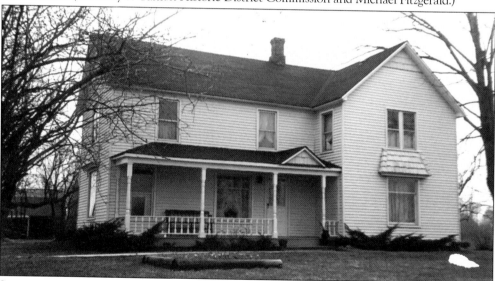

SEYMOUR HOME. A large, rambling farmhouse surrounded by acres of fields sits on Geddes Road near the western border of Canton Township on land that has been in the Seymour family since 1847. The house boasts a wide front porch and gleaming white siding. There is an official centennial farm sign proudly displayed on the front lawn. The house is significant for its architecture. It is a very good example of the L-shaped farmhouse built between 1850 and 1880 in the Midwest. It is also an example of post and beam construction. (Courtesy of Canton Historic District Commission.)

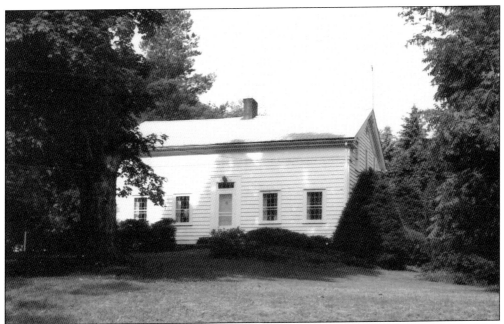

PATTERSON-GILMORE HOME, 6205 NORTH RIDGE ROAD. Constructed around 1840 by John Patterson and his second wife, Eliza Barr, this one-and-a-half-story Greek Revival home was significantly renovated in the 1930s by William and Florence Gilmore. The replacement clapboard, roof, and wood windows are in keeping with its historic architecture. (Courtesy of Canton Historic District Commission and Michael Fitzgerald.)

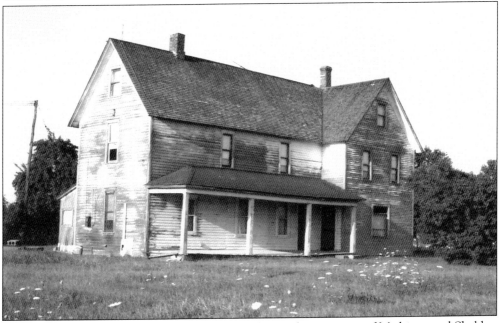

JAMES RUSSELL HOME. On two acres of land at the southwest corner of Michigan and Sheldon Roads, James Russell built a large home and a blacksmith shop that served the community of Sheldon Corners for many years. (Courtesy of Canton Historic District Commission and Michael Fitzgerald.)

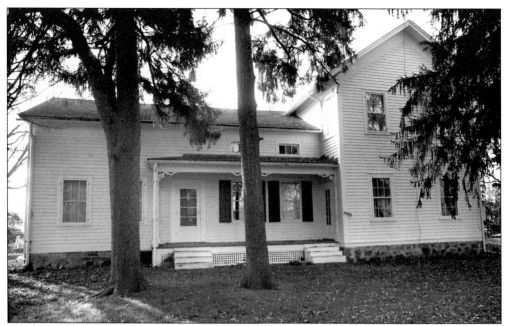

BURCH-FOEGE HOUSE, 43655 JOY ROAD. An excellent example of Greek Revival architecture, the Burch-Foege house is one of the oldest homes still standing in Canton Township and is also noteworthy for the number of agricultural outbuildings that remain on the property, including a pump house, summerhouse, privy, granary, barn, smokehouse, greenhouse, windmill, and two silos. (Courtesy of Canton Historical Society.)

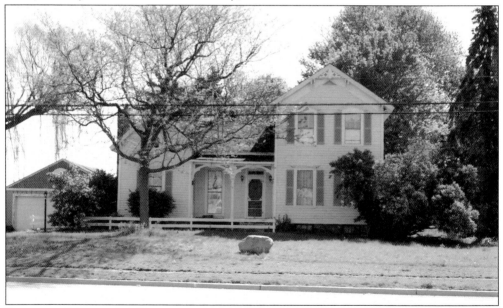

DINGELDEY HOME, 1638 HAGGERTY. Around 1890, Canton pioneer Phillip Dingeldey moved his wife Maria and their eight children further north on Haggerty from his original home south of Palmer, where he had already established a reputation as a winemaker. Built originally around 1850, the home today is one of the most significant residential structures in the township, likely refurbished from an original upright and wing style to today's Italianate style with some Gothic details.

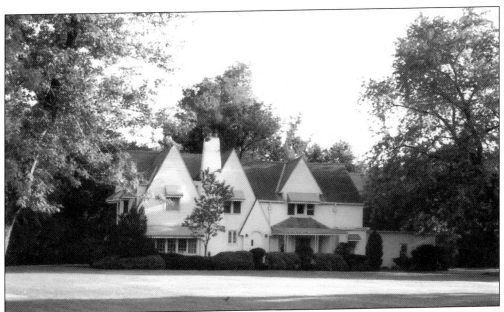

STEIN-SMITH HOME, 41822 MICHIGAN AVENUE. Following his marriage to Marie Stein in 1921, Andrew Smith supervised a major remodeling of his new bride's early-20th-century family home. Michigan Avenue was being widened, and the Stein home was moved back from the highway and turned around so that the front of the house faced the road. At the same time, its exterior appearance was changed by the addition of a new roofline with several very steep gables and brand-new awnings in the windows. (Courtesy of Canton Historic District Commission and Michael Fitzgerald.)

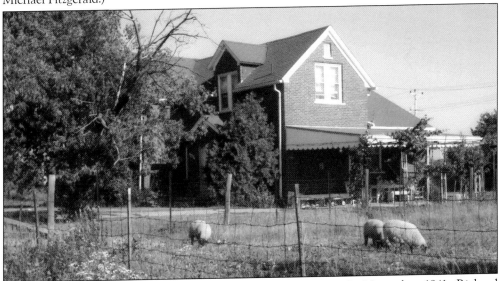

McGRAW/COSTANTINO FARM, 45960 CHERRY HILL ROAD. In November 1841, Richard McGraw purchased the first two parcels of land in Canton's section 16, located on the northwest corner of Cherry Hill and Canton Center Roads. In the 20th century, the land was farmed by Guido and Rose Costantino, the produce from which was prepared and served at Canton's popular Rose's Restaurant, located at the extreme corner of the same intersection. (Courtesy of Canton Historic District Commission and Michael Fitzgerald.)

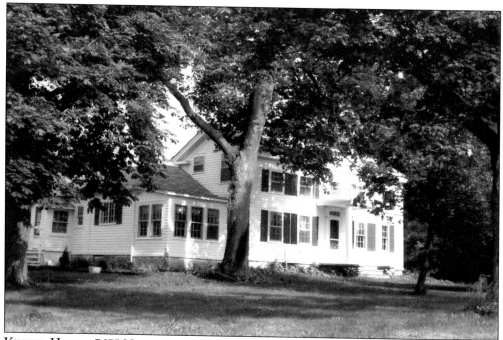

KINYON HOUSE, 7675 NORTH RIDGE ROAD. Built by Orrin Kinyon and Roxanna Kinyon (née Fairman) around 1850, the Kinyon house represents a form of the Greek Revival style that was brought to Michigan by settlers from New England and New York during this period. The large and prominent Kinyon family was engaged in farming and was very active in the community. (Courtesy of Canton Historic District Commission and Michael Fitzgerald.)

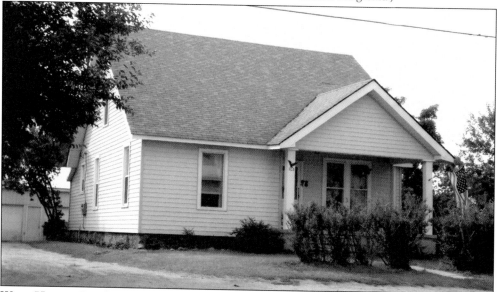

WEST HOUSE, 703 SOUTH RIDGE ROAD. First built in 1922, the house of Stanley and Dorothy West has undergone significant alteration. The house is significant because of its association with the West family, which has been an integral part of the history of Cherry Hill in the 20th century. It was constructed specifically as a residence in the village of Cherry Hill with no associated farm property. (Courtesy of Canton Historic District Commission and Michael Fitzgerald.)

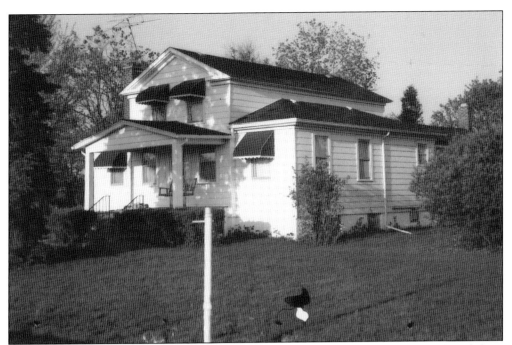

CARLETON HOUSE, 1850 SOUTH CANTON CENTER ROAD. On property purchased from Timothy Sheldon, Milton Carleton established a thriving clay-field-tiles industry. John Haggerty bought the estate from Milton in 1918 and moved the above premises further north. (Courtesy of Canton Historic District Commission and Michael Fitzgerald.)

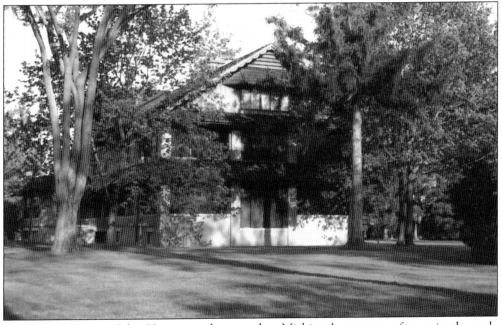

HAGGERTY ESTATE. John Haggerty, who served as Michigan's secretary of state in the early 1920s, built this fine home on the former Carleton estate and divided his time between here, chiefly in the summer months, and his home in Dearborn, known at the time as Springwells. Henry Ford was a good friend of Haggerty and an occasional visitor to the Canton residence.

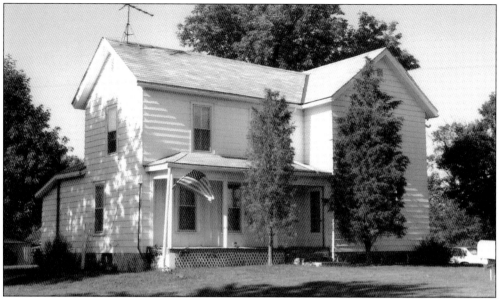

LEWIS-WILKIE HOUSE, 50221 CHERRY HILL ROAD. This house is of historical importance in the settlement of Cherry Hill Village. Early settlers Samuel and Assenath Lewis were typical of a large number of New Yorkers who migrated west in search of a better life after the opening of the Erie Canal. Samuel purchased the original land patent in 1832 and farmed it for many years. The land remained in the Lewis family until 1924. Despite its present aluminum siding, the house retains much of its original appearance. (Courtesy of Canton Historic District Commission and Michael Fitzgerald.)

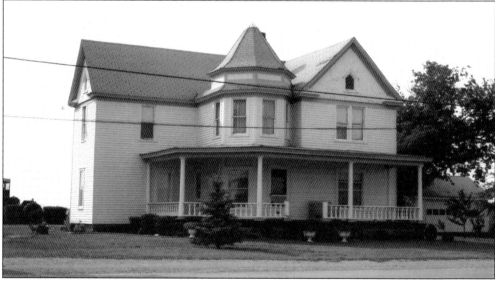

HORNER/HAUK FARM, 801 SOUTH RIDGE ROAD. Thomas Horner's Canton farm at 801 South Ridge Road was on land originally granted to Michael Roberts in 1826. Thomas Horner's son Henry recalled in a published interview that a variety of foodstuffs—corn, wheat, oats, potatoes, cattle, hogs, turkeys, and chickens—were plentiful on his father's farm through much of the latter half of the 19th century. The farm was purchased and subsequently farmed by Henry Hauk and Mary Hauk (née Jorgenson). (Courtesy of Canton Historic District Commission and Michael Fitzgerald.)

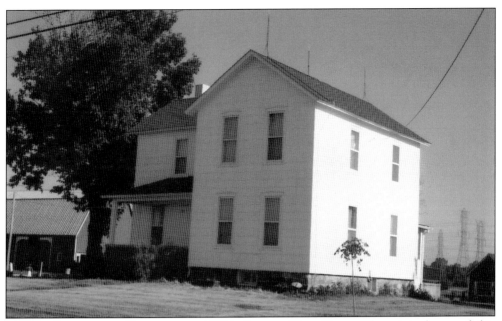

HUSTON-JAKUBOWSKI FARMHOUSE, 48030 CHERRY HILL ROAD. The original part of this historic Canton farmhouse on Cherry Hill Road was built around 1850 by John Huston, the son of Canton pioneers, William and Mary Huston. General farming was done on the 80-acre farm. The agricultural census for 1850 indicates that the farm produced 33 bushels of wheat, 400 bushels of corn, 340 bushels of oats, 200 bushels of potatoes, and produced 500 pounds of butter from six cows. This farm is currently owned and operated by Jake and Betty Jakubowski. (Courtesy of Canton Historic District Commission and Michael Fitzgerald.)

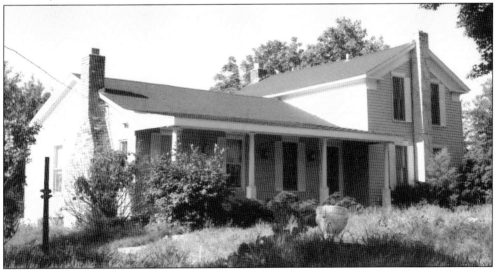

PHELPS-MOYER HOME, 50135 HANFORD ROAD. Although this Hanford Road house has been significantly altered since it was built in 1847, this Greek Revival house, with gable front and wing, is historically significant. Philomen Phelps bought the west 100 acres of the original land grant from Albert Fellows in 1841. Because of a substantial increase in taxes between 1847 and 1848, it is surmised that the house was built at that time. (Courtesy of Canton Historic District Commission and Michael Fitzgerald.)

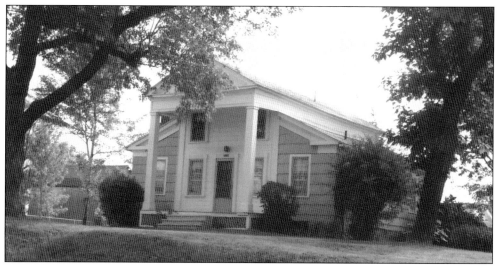

BOLDMAN-OSBORNE HOUSE, 3339 SOUTH CANTON CENTER ROAD. Settlers from New York and New England brought Greek Revival architecture to Michigan, and no example in Canton Township is more significant than the Boldman house, built between 1840 and 1845, shortly after David Boldman purchased the property in 1839. This form of the basilica type of architecture is considered unique to Michigan. The house is also important in Canton's agricultural history in that a cheese factory was once located on the farm. (Courtesy of Canton Historic District Commission and Michael Fitzgerald.)

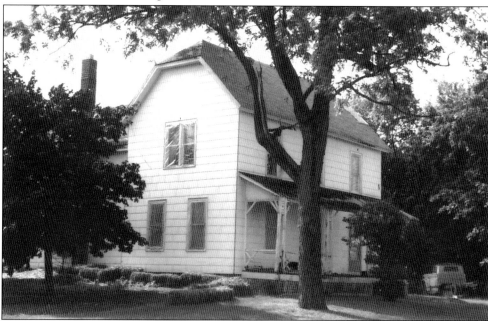

KELLY-THEISEN FARMHOUSE, 2260 RIDGE ROAD. Located on the corner of Ford and Ridge Roads, the 116-acre farm was purchased from the Kelly family in 1929 by Peter and Mary Elizabeth Theisen of Dearborn. Peter sent his three sons, William and twins Edward and Walter, to make their living on the Canton farm, where they subsequently raised grain and kept a dairy herd. The farm remained in the Theisen family until 1971. (Courtesy of Canton Historic District Commission and Michael Fitzgerald.)

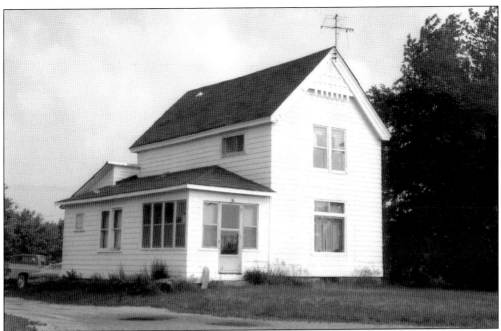

CORWIN HOME, 2105 RIDGE ROAD. Milo Corwin, grandson of Canton pioneers Jesse Corwin and Sarah Corwin (née Hulet), married Grace Mae Franklin, whom he met while working as a motorman on the interurban that ran between Northville, Plymouth, and Wayne. The couple lived in several different homes throughout Plymouth and Canton before settling down to raise four children on this Ridge Road farm, just south of Ford Road. The farm remained in the Corwin family until 1977. (Courtesy of Canton Historic District Commission and Michael Fitzgerald.)

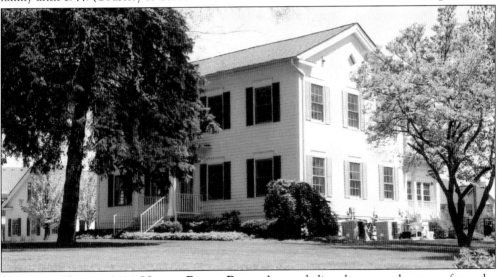

HANFORD HOUSE, 6430 NORTH RIDGE ROAD. Located directly across the street from the former Hanford School, this historic farmhouse sits on land that was granted to James Hanford in 1826. The farmhouse remained in the Hanford family until the 1940s, after which Jeff Brown, a local developer, purchased, refurbished, and resold the property to private owners. During the Depression the Hanfords converted much of the premises to lodgings for farmers who lost their property during the ensuing economic collapse.

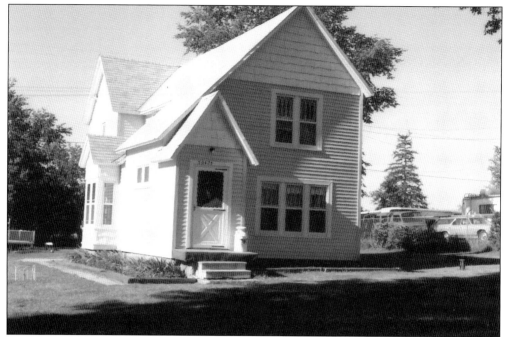

COMER-WEST HOUSE, 50475 CHERRY HILL ROAD. The original house on this site was built by John and Almira Cody in 1852 as a reflection of their growing affluence. Following John's death in 1859 the property was owned by a succession of small-trades people who both lived and worked in the hamlet of Cherry Hill. George Comer, a grocer, built the present house in 1884, and it was purchased by William and Louisa West in 1920. The West family operated the general store in Cherry Hill from the early part of the century until the 1960s. (Courtesy of Canton Historic District Commission and Michael Fitzgerald.)

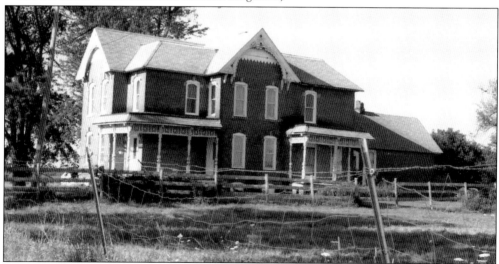

TRUESDELL HOMESTEAD, SIDE VIEW. This gracious brick home was built shortly after the Civil War by Ephraim Truesdell, son of Erastus and Calist, who first settled the property around 1840. Ephraim, a volunteer who fought with the 4th Michigan Calvary and reputedly helped capture Jefferson Davis, president of the Confederacy, returned home wounded and missing a lung. (Courtesy of Canton Historic District Commission and Michael Fitzgerald.)

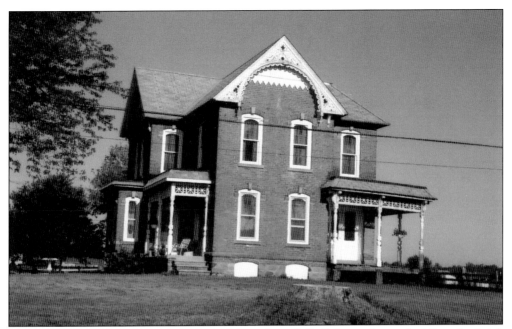

TRUESDELL HOMESTEAD, FRONT VIEW. Married in 1869, Ephraim began building the brick two-story, cross-plan house from bricks hauled from John Haggerty's Brick Company. A mix of Italianate and Queen Anne influences, the house was listed on the Canton Local Historic Registry in 1985. (Courtesy of Canton Historic District Commission and Michael Fitzgerald.)

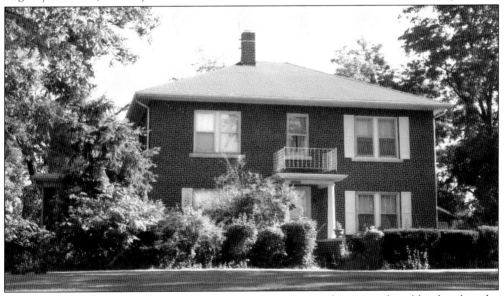

WILLIAM HAUK HOUSE, 50530 CHERRY HILL ROAD. Located on agricultural land within the village of Cherry Hill, the William Hauk house is a good example of the type of larger home being built in rural Canton in the early 20th century. Its orientation to Cherry Hill Road, as well as its refinement of style, suggest a far more urbane setting. As the house was being constructed, William and Jennie Hauk lived in the Thomas Clyde house located on the same property. The house is currently a dentist's office. (Courtesy of Canton Historic District Commission and Michael Fitzgerald.)

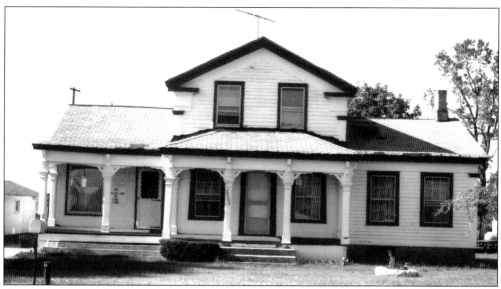

THOMAS CLYDE HOUSE, 50325 CHERRY HILL ROAD. This house is significant for both historical and architectural reasons. Built around 1845 by the son of early Canton pioneers Eliza Clyde (née Huston) and Hugh Clyde, the Thomas Clyde house was occupied after 1858 by John Huston II, who was active for many years in township government. In 1924, it was purchased as a first home by Jennie and William Houk. After a new brick home was built on the same property, the Thomas Clyde house was moved across the street to the William West property at 50325 Cherry Hill Road. This upright with a double wing form was once a common house form during the period of settlement and early development. (Courtesy of Canton Historic District Commission and Michael Fitzgerald.)

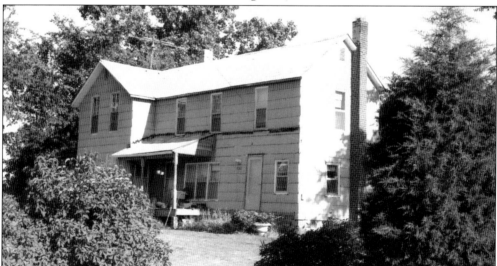

COLE-WILES HOME, 46870 CHERRY HILL ROAD. The 19th-century log cabin home of John Cole and Hilda Cole (née Hartwell) was moved from its original low-lying spot on the farm to higher ground. Over the years, the home underwent three major additions, including a second floor, and was entirely covered with asphalt siding. The home's original log beams can still be seen in the basement. Crosswinds Church presently owns the property. (Courtesy of Canton Historic District Commission and Michael Fitzgerald.)

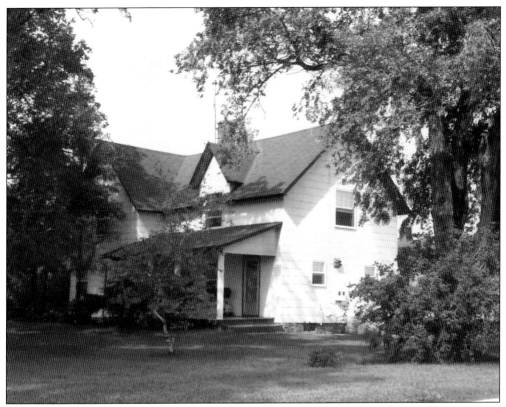

GOTTS FARM. On land originally granted to Welcome Bird in 1829, Edgar and Lottie Gotts and their two children, Percy and Fannie, settled here in April 1908. The family became active members of the Cherry Hill Methodist Church and children and grandchildren attended Cherry Hill School. Much of the farm is now the site of Knollwood Cemetery, but the old farmhouse is presently occupied by the Doumanian family. (Courtesy of Canton Historic District Commission and Michael Fitzgerald.)

GOTTS FARM, ARTIST'S RENDERING. The simple beauty of a successful Canton farm is reflected in this pen-and-ink sketch by Polly Anne Richards Blackburn, daughter of Dorothy Richards (née Gotts) and Robert H. Richards, and great-granddaughter of early farm settlers Edgar and Lottie Gotts. (Courtesy of Polly Anne Richards Blackburn.)

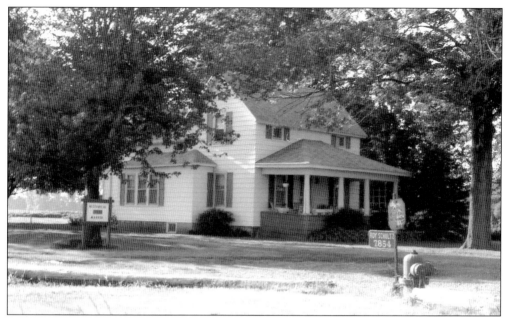

ROY SCHULTZ CENTENNIAL FARMHOUSE, 7854 NORTH LILLEY ROAD. Originally part of the vast Safford property holdings on both sides of Lilley Road, the Roy Schultz farm was a consistent producer of corn and melons in Canton's heyday as "the Corn Capital of Michigan." (Courtesy of Canton Historic District Commission and Michael Fitzgerald.)

ROY SCHULTZ FARM. The Schultzes, Roy and Tillie, purchased the former Gottschalk home and farm in 1945. From 1946 forward, Roy and Tillie Schwartz engaged in many farming enterprises. They raised chickens and eggs, sweet corn and other vegetables, grain, dairy cattle, beef cattle, and hay and straw. From 1970 to 1981, the Schultzes grew "U-Pick" strawberries and vegetables and operated a produce stand. (Courtesy of Canton Historic District Commission and Michael Fitzgerald.)

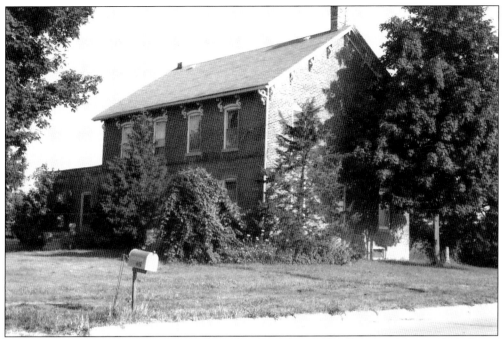

JAMES WILES HOME, 1451 SOUTH LILLEY ROAD. Soon after his marriage to Ann James McKinstry on August 5, 1850, Canton pioneer James Wiles settled in with his 18-year-old bride on wilderness property originally granted to Daniel Van Etten in 1834. Their brick home is noteworthy for being built deliberately in the path of new road construction. Driving south on Lilley Road today requires a swerve to the left and a swerve to the right to avoid driving directly into the house. (Courtesy of Canton Historic District Commission and Michael Fitzgerald.)

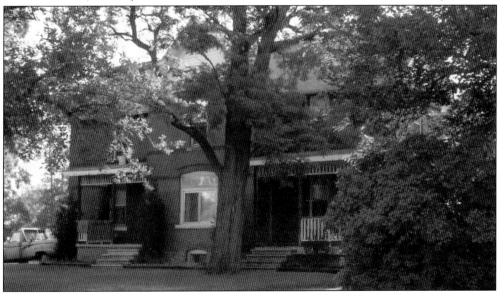

JOHN WILES HOME, 5405 SOUTH LILLEY ROAD. Born in Skipwith, England, in 1837, John Wiles settled on property south of Michigan Avenue with wife Lydia and five children. By 1893, a total of five Lilley Road farms were in the possession of various Wiles families. (Courtesy of Canton Historic District Commission and Michael Fitzgerald.)

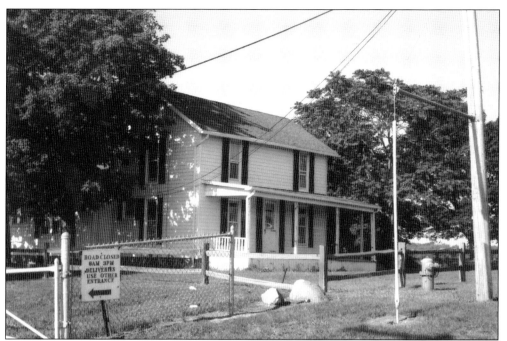

SCHOOL FARMHOUSE. Today's Plymouth-Canton Educational Park, a 305-acre campus that is home to three high schools, was the former David D. Cady farm, established in 1827. John William Cady, grandson of David D., finished building this farmhouse on the Cady property during the first decade of the 20th century. After the Second World War, the property was purchased by the school system as a demonstration farm. (Courtesy of Canton Historic District Commission and Michael Fitzgerald.)

SCHOOL BARN. Constructed in 1908, the Cady barn was located, along with several outbuildings, behind the Cady farmhouse. Today the farmhouse is gone, as well as all the outbuildings, but as of mid-2006, the barn remains as the last vestige of the Cady farm. Long-time Canton resident Bob Boyer came forward in June 2006 to personally provide most of the funding to dismantle and move the barn to Cherry Hill Village, near the Bartlett-Travis House. (Courtesy of Canton District Commission and Michael Fitzgerald.)

Six

"FROM A PROUD PAST TO A STRONG FUTURE"

One measure of the vitality of a community is the balance it strikes between preserving the past and embracing the future. In 1984, Canton Township celebrated its sesquicentennial at a time of tremendous growth and development. The motto of the celebration, appearing on its commemorative medallions and in various publications, was "From a proud past to a strong future."

Among the many projects that the township has undertaken to underscore its commitment to local history and culture are the Bartlett-Travis House, Cherry Hill School, Canton Historical Museum, and the Village Theater.

Private interests have also contributed significantly to preserving landmark structures. In Cherry Hill Village, for example, a number of architecturally and historically important homes have been refurbished by residents with deep ties to the community. Larger projects have been undertaken as well, none more significant than Scott Colf's magnificent renovation of the Cherry Hill Inn.

Canton Township continues to celebrate its agricultural heritage in the many festivals that have been privately and publicly sponsored. In the late 1970s, several community leaders such as Frank McMurray and John Swartz were instrumental in encouraging local farmers to stage a huge corn roast in Griffin Park. With family games, ice cream, and music, the Sweet Corn Festival was very popular for a number of years.

As Canton began to feel the growth boom of the 1980s, the Sweet Corn Festival faded away as many of the local farmers sold off their land west of Canton Center. In its place, the Canton Country Festival filled the void and provided Canton residents with many summertime events and activities.

The early 1990s saw a renewed commitment to a community festival. Heritage Park was developed and became the focal point for organized activities in the community. Liberty Festival, now in its 16th year, is a safe, family friendly community event that is a true celebration of Canton, its diversity, its culture, its past, and its future.

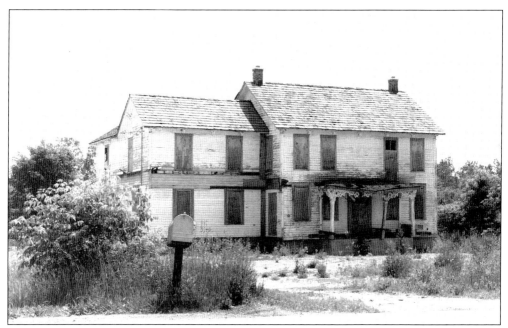

BARTLETT-TRAVIS HOUSE AT ORIGINAL LOCATION. Originally built in 1838 and located on Canton Center Road south of Warren Road, the Bartlett-Travis House was donated to the township by local realtor Kev Dividock in 1988. The house was moved the next year to Cherry Hill Village, where restoration began in 1994 and was completed in 2002. (Courtesy of Canton Historical Society.)

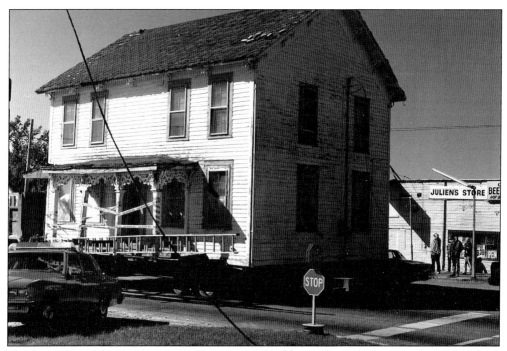

THE BIG MOVE. The Bartlett-Travis House was moved by truck to its present site in 1989, where it was placed on a new foundation and a new roof and chimney were added. (Courtesy of Canton Historical Society.)

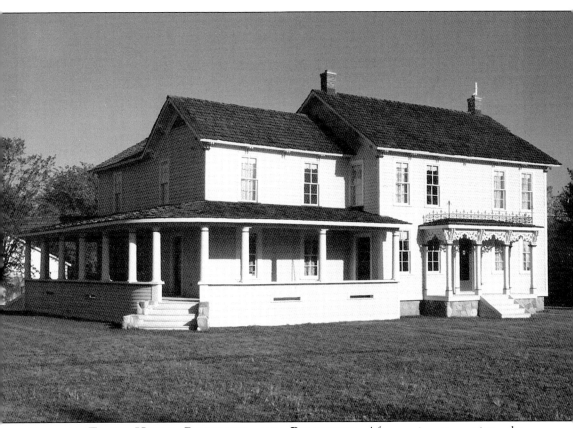

BARTLETT-TRAVIS HOUSE, RENOVATED AND RELOCATED. After major renovation, the Barlett-Travis House is now open for tours and is used frequently by both township and private concerns for special events. Along with Cherry Hill School and the Cherry Hill Inn, the Bartlett-Travis House is considered one of Cherry Hill Village's most polished jewels. (Courtesy of Canton Historic District Commission.)

CANTON POLICE RESERVES. Prior to 1976, Canton Township was served by the Wayne County Sheriff Department, supported by a group of volunteer local reserves, pictured here in a photograph from 1975. (Courtesy of Canton Department of Public Safety.)

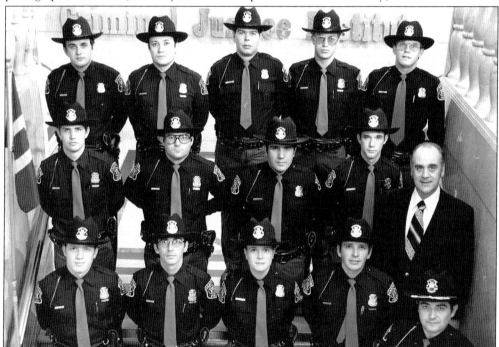

FIRST CERTIFIED POLICE OFFICERS. On November 19, 1976, fourteen officers graduated from the Criminal Justice Institute and joined the Canton Police Department. They are, from left to right, as follows: (first row) Kurt Johnson, George Sharp, Kathy Petres, Eddie Tanner, and Chief Robert Greenstein; (second row) Davey LeBlanc, Kenneth Winklet, Bruce Roderick, Robin Cripe, and Carl Parsell, director of the Police Officers Association of Michigan; (third row) John McDiarmid, Roger Pearsall, Daniel Antieau, Robert van Lith, and Leonard Bush. (Courtesy of Canton Department of Public Safety.)

Canton's First Parade. As part of the Canton Country Festival in 1981, organizers began a tradition that continues today—a parade of farmers, floats, families, and fun! Parade participants marched down Ford Road, from Haggerty Road at the east end to Canton Center Road. (Courtesy of Canton Historical Society.)

Chicken Barbecue. The centerpiece of the Canton Country Festival, which began in 1981 and concluded in 1984, was the Sunday chicken barbecue that drew hundreds of Canton families to Griffin Park for a complete dinner and renewal of acquaintances. (Courtesy of Canton Historical Society.)

Cow Chip Queen. Another tradition that lasted the duration of the Canton Country Festival was the selection of a Cow Chip Queen and her court, celebrated on a festival float on Ford Road. (Courtesy of Canton Historical Society.)

Tug of War. One of several popular Canton Country Festival events, the tug of war between Canton firefighters and administrative personnel resulted in the firefighters receiving a thorough dunking. (Courtesy of Canton Historical Society.)

RODEO CANTON. Canton's farm heritage included not only cattle and grain production but also a love of horsemanship. In 1981, the Canton Country Festival showcased local equestrian skill by sponsoring its first—and only—rodeo. (Courtesy of Canton Historical Society.)

CALF ROPING, 1981. Canton's first rodeo was held in Heritage Park, just off Civic Center Drive. Although it rained for much of the day, a large community turnout made the event a success. Citizens were thrilled by the various rodeo events, including calf roping, which is pictured here. (Courtesy of Canton Historical Society.)

DOWNER CEMETERY. Located on "Old" Michigan Avenue, Canton's oldest cemetery is located on high ground overlooking Michigan Avenue at Haggerty Road. On land granted by Lucretia Downer, who is buried here, the cemetery is currently inactive but open to the public for viewing headstones.

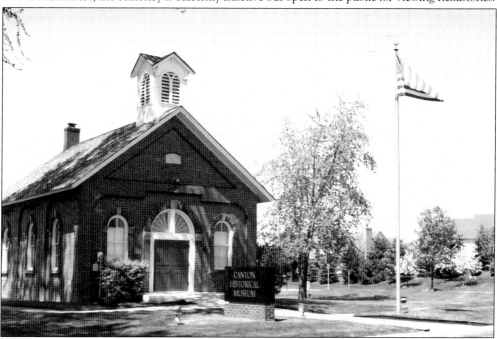

CANTON HISTORICAL SOCIETY AND MUSEUM. Formally established in 1977, the historical society immediately acquired and renovated the former Canton Center School for its museum. The building now houses an extensive collection of artifacts, documents, and photographs that trace the history of Canton Township.

FIRST FIRE TRUCK. In 1950, the township organized a volunteer fire department and purchased its first fire truck. The pumper was housed at the first fire station at Geddes and Sheldon Roads and later at a new station at Canton Center and Cherry Hill Roads. The township's only full-time fireman, Larry Longwish, lived at the station with his family. When a call came in, Longwish would sound the alarm and head for the fire while his wife would answer the phone to tell the volunteers where the fire was. The old fire station has been torn down, replaced by a state-of-the-art station near the municipal complex and a second station on Warren Road. The volunteers have been replaced by crews of professional firefighters trained as paramedics and in advanced life support. (Courtesy of Canton Historical Society.)

KINYON CEMETERY. Located on Gyde and Ridge Roads, Kinyon Cemetery sits on land purchased originally from Moses Bradford in 1840 and later expanded, in 1908, through a purchase of additional acres from the James Bradley estate. At that time lots were sold for $10.

NATIVE AMERICAN TRAIL MARKER. Local legend has it that this particular conifer in Kinyon Cemetery was a Native American trail marker. It was common for such markers to be created by bending and tying down a branch, forcing it to point in a certain direction. This particular conifer points southwest to Ypsilanti and northeast to Plymouth.

SESQUICENTENNIAL TIME CAPSULE. A marker identifies Canton's time capsule containing representative documents and artifacts, buried in a vault several feet underground on land adjacent to the Canton Historical Museum.

CANTON SESQUICENTENNIAL BALL. Dressed in period costumes, 240 people attended Canton's birthday party, held at the UAW Hall on Michigan Avenue on March 10, 1984. Here a few of the ladies in attendance pose for pictures in front of a covered wagon in the parking lot adjacent to the Roman Forum restaurant on Ford Road. (Courtesy of Canton Historical Society.)

CURTSEYING FOR THE BALL. Elaine Lavander practices curtseying in the living room of her Canton home just prior to the 1984 Sesquicentennial Ball. Elaine made the authentically styled early American dress herself from a pattern that required eight yards of material. (Courtesy of Elaine Lavandar.)

CHERRY HILL CEMETERY. Located on the east side of Ridge Road, south of Cherry Hill Road, this private cemetery has been operated and maintained since 1905 by the Cherry Hill Cemetery Association. The land was originally granted by John B. Figuet, and burials began around 1840.

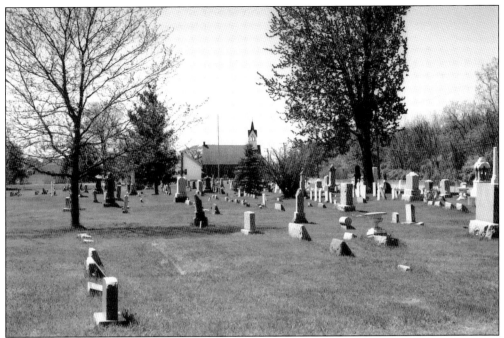

CHERRY HILL CEMETERY VISTA. Resident families of the historic hamlet of Cherry Hill are well represented in the cemetery adjacent to the Cherry Hill Methodist Church. Family names include Dunstan, Gill, Gunn, Huston, Houk, Newton, Truesdell, and Westfall.

VETERANS MEMORIAL DEDICATION. On June 25, 1993, Canton's Veterans Memorial was officially dedicated in Heritage Park to honor the memory of all military personnel from Canton Township who have served the country—past, present, and future. (Courtesy of Canton Historical Society.)

THE SUMMIT ON THE PARK. Opened in January 1996, Canton's community center is a 95,000 square foot cultural and recreational jewel in the heart of the 105-acre Heritage Park. The $16 million complex includes a wide array of outstanding cultural and recreational amenities. Its unique design is topped by a 75-foot-high glass tower and massive copper and glass superstructure. The Summit is open year round to residents and nonresidents. (Courtesy of Canton Leisure Services.)

THE VILLAGE THEATER AT CHERRY HILL. Canton's performing arts center, located on the northwest corner of Cherry Hill and Ridge Roads, is a 400-seat theater devoted to quality cultural enrichment and community-minded programming. Opened in the fall of 2004, the Village Theater is operated by Canton Leisure Services and supported by the partnership for the Arts and Humanities, Inc. (Courtesy of Canton Leisure Services.)

CANTON TOWNSHIP ADMINISTRATION BUILDING. Opened in 2004, the new administration building houses five departments: administrative and community services, finance and budget, leisure services, municipal services, and public safety. Canton's ruling body is the board of trustees, made up of seven elected members, of which three are full-time administrators and four are part-time trustees. The full-time elected officials are the supervisor, treasurer, and clerk. They also oversee the day-to-day administrative operations of the township. (Courtesy of Canton Administration.)

KNOLLWOOD CEMETERY, 1299 RIDGE ROAD. North of Cherry Hill Road, Knollwood Cemetery sits on land that was once part of the Gotts farm. The cemetery is privately owned and managed.

CHERRY HILL INN, 2005. Built originally in 1864 by Abner Hitchcock, the 6,000-square-foot inn remains the crown jewel of the historic corner of Cherry Hill and Ridge Roads. In the summer of 2002, former commercial airline pilot Scott Colf purchased and thoroughly renovated the Italianate-style building. The building currently houses the Cantonian Market on the first floor and a salon on the second floor, where the old dance hall used to be. Plans are underway for additional commercial occupancy. (Courtesy of Canton Historical Society.)

SHELDON CEMETERY. Many early pioneers and their descendants have been interred at this historic Canton cemetery on Sheldon Road, north of Michigan Avenue. Among the prominent early residents of Canton include Timothy Sheldon; Eliphalet Carleton, who, at the age of 19, died of wounds received at the Battle of Gettysburg in 1863; John and Marie Dingeldey; and several Truesdells. One of saddest memorials in the cemetery honors the five Lohr children, who succumbed to an epidemic between March 15 and March 21, 1871.

SHELDON CEMETERY WALK. Dave Curtis, Canton Historical Society board member and local historian, conducts a tour of Sheldon Cemetery, with particular emphasis devoted to Civil War veterans who made their home in Canton Township.

BIBLIOGRAPHY

Canton Township Agricultural Survey. Canton, MI: Kosky and Glynn Associates, 1996.

Canton Township Agricultural Survey II. Canton, MI: Kosky and Glynn Associates, 1999.

Palmer, Joan Cavell. *Canton's Country Schools*. Canton, MI: Canton Historical Society, 1993.

2002 Supplement to Canton Township Agricultural Survey II. Canton, MI: Kosky, Glynn, and Saborio, 2002.

Wilson, Diane F. *Cornerstones: A History of Canton Township Families*. Canton, MI: Canton Historical Society, 1993.

INDEX

DISCOVER THOUSANDS OF LOCAL HISTORY BOOKS FEATURING MILLIONS OF VINTAGE IMAGES

Arcadia Publishing, the leading local history publisher in the United States, is committed to making history accessible and meaningful through publishing books that celebrate and preserve the heritage of America's people and places.

Find more books like this at
www.arcadiapublishing.com

Search for your hometown history, your old stomping grounds, and even your favorite sports team.